WITHDRAWN

D0477853

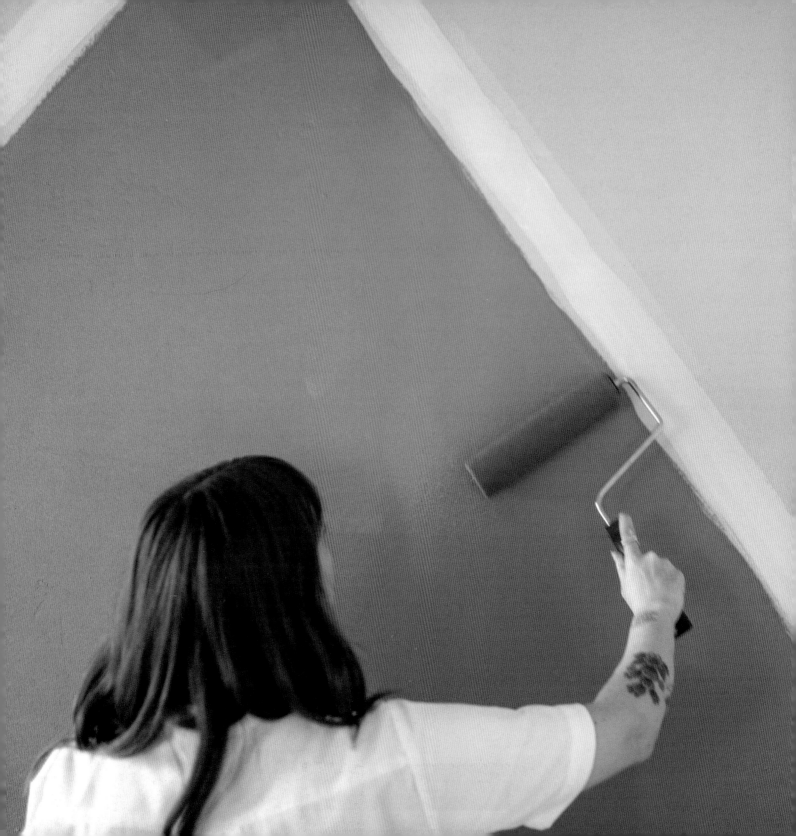

PHOEBE CORNOG & ROXY PRIMA

Wonder
WALLS

HOW TO TRANSFORM YOUR SPACE
with Colorful Geometrics, Graphic Lettering,
and Other Fabulous Paint Techniques

Storey Publishing

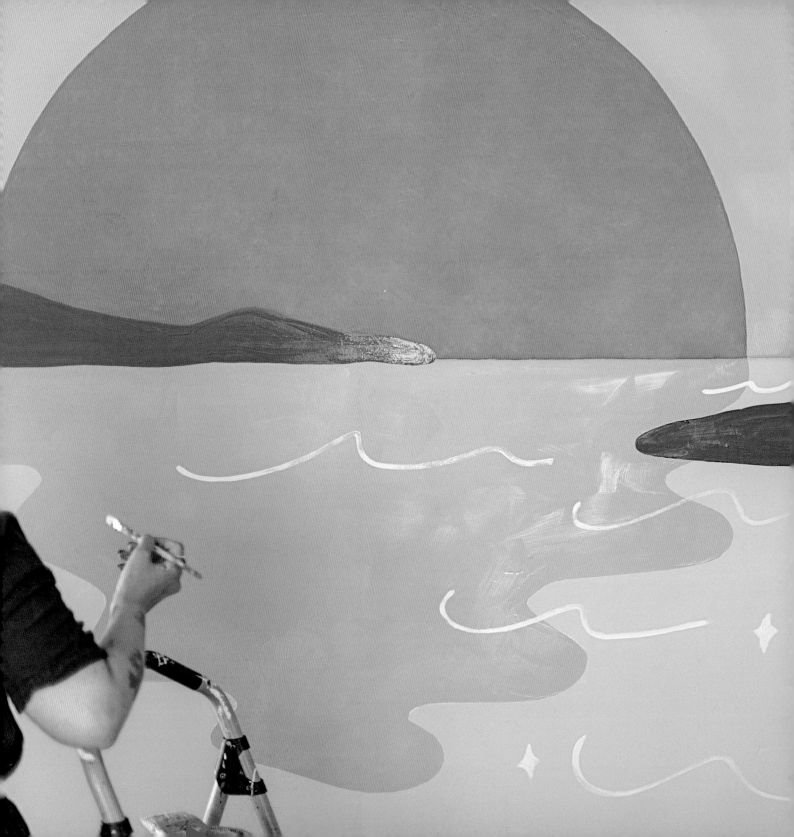

This book is dedicated to everyone who has ever wanted to paint a mural but has never had the courage. You can do it!

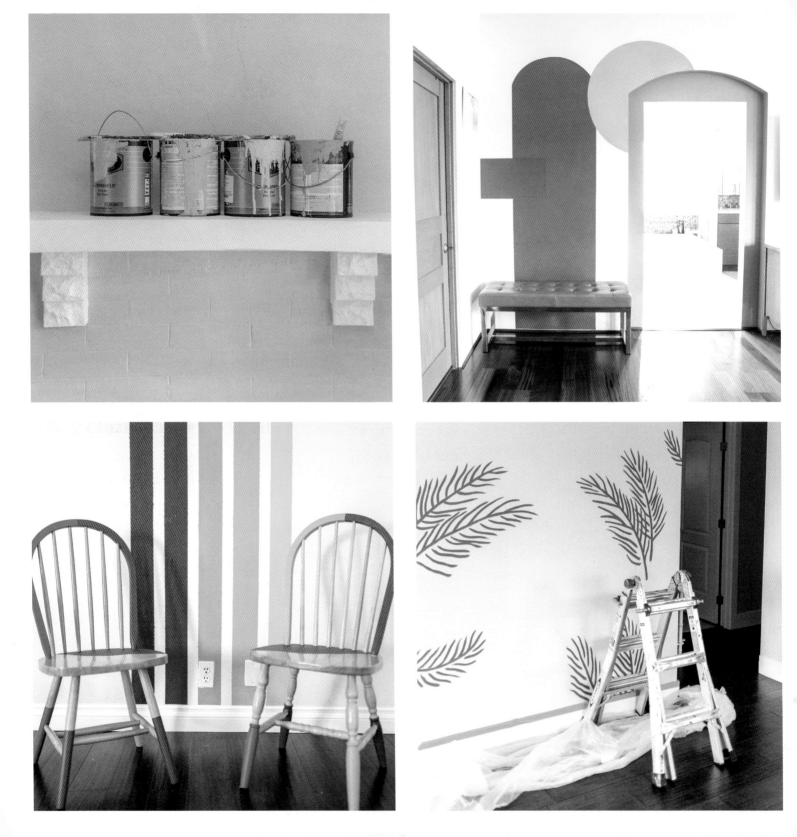

CONTENTS

Our names are Phoebe Cornog and Roxy Prima, and we are graphic designers-turned-muralists, and now authors. Our collective story began in 2015, when Phoebe slid into Roxy's DMs on Instagram with the hope of meeting up for wine and a chat about design. From there the story turns totally cliché about starting a meetup, quitting our jobs, painting murals professionally, and then writing a book. You've heard it a thousand times before.

At our very first meeting, we were immediately inspired and brought out so many ideas in one another. We created a meetup for letterers and hosted monthly events around San Diego. We held free events on such wide-ranging topics as making letters out of food for Thanksgiving, making signs before a Padres game (and of course getting on the jumbotron), and painting a mural as a group—which was the first time either of us had painted on a wall. From planning those events, curating the social media, and branding the club, we found that we worked really well together. Phoebe's social charm and ability to talk to anyone and Roxy's independent spirit and ideas, mixed together with creativity from each of us, proved a great combination.

At the time, we both had full-time day jobs as graphic designers. Phoebe's job was creative and she got to have a lot of fun, but after a year she realized it offered her no upward mobility. Roxy's job was not creative at all, but it was easy and gave her lots of time to work on freelance projects.

We didn't know we'd become professional muralists. All we knew is that we both craved something more hands-on and were sick of sitting behind computer screens for 40 hours a week. Running our meetup initially gave us a creative outlet to make something of our own, but it didn't take long until we wanted more. We started talking about our goals and our dream projects, and one of those (for both of us) was to paint a mural as a freelance project. We just wanted to paint one mural. Little did we know there were hundreds of murals in our future.

We are big fans of putting our goals out there, so we promptly started telling people and posting on social media about wanting to paint a mural for a business. And what do you know? Someone responded and said their business needed a mural. If we have one piece of advice to give you, it would be to tell everyone about your dreams and goals. Tell everyone, and they will happen! Anyway, we got the job. We painted the mural, totally undercharged for it, learned a lot, didn't mess up the wall, and fell in love with the process.

We posted that first mural on Instagram and got some engagement. Soon afterward, someone else reached out about us painting a mural for their business, which spiraled into requests for more. We quit our day jobs and founded Pandr Design Co.

We've now painted more than 250 murals, and there's no stopping us! We are officially obsessed. Over the past few years, we've gotten to travel all over the country and even to a few places in other parts of the world to paint murals. Shout-out to Tasmania! Yes, that's right, we got hired to paint a mural in Tasmania. We've worked with Target; Lululemon; Major League Baseball, National Football League, and National Basketball Association teams; Visa; Red Bull; and many other dream clients.

Aside from running Pandr full-time, we also have a nonprofit called Ladies Who Paint. We like to keep busy!

Ladies Who Paint is the first all-female mural festival, which we hosted for the first time in 2019. We brought 10 female muralists to San Diego, and each painted a large-scale mural. Our mission is to empower female artists, give them the recognition they deserve, and beautify our hometown. If you'd like to follow along and check out some amazing art from ladies all over the world, make sure to follow @ladieswhopaint on Instagram.

GET SOCIAL

As you go through the projects in this book, assess your space, and inevitably decide to paint your wall, make sure to share. It's okay to snap some pics and brag about your accomplishments on social media.

And we want to see what you're up to! Use the hashtag #paintlikePandr and tag us, @pandrdesignco, on your posts and stories so we can take a look. We might even feature you as one of our star students!

Also, make sure to follow us on Instagram (@pandrdesignco) and TikTok (@phoebecornog and @roxyprima), and check out our website for more resources: www.pandrdesignco.com.

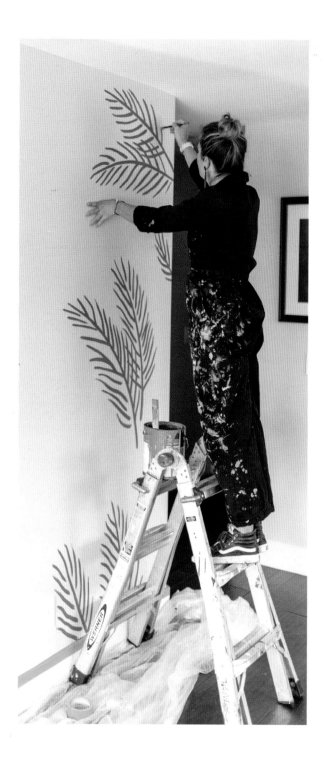

GETTING THE MOST OUT OF THIS BOOK

This easy-to-follow guide is your key to customizing your space. After all, you have to look at that space every day, so it might as well be something that you love. Even if you have no painting experience at all, we know you'll find something that speaks to you in this book's 26 projects.

Painting a wall can seem like an intimidating process, but you got this! You can turn your space into your own personal zen den that makes you feel at peace after a long day of work. Or maybe you want to make a bright, colorful space that feels like your own little haven of happiness. Let's do it! Perhaps you're more of a neutral person; that's cool, we got you! Maybe you're looking for a way to make a small space feel bigger and more inviting. We can show you how to do that, too.

With your own paint color choices, you can customize any of our step-by-step guides to create something that is 100 percent you. Whatever your space, whatever the room, you will find tips and tricks in this book that will help you create something as beautiful and unique as you are. Once you start considering the possibilities, you will never look at a blank wall the same.

Don't get us wrong; painting a mural can get messy, but we'll be walking you through step-by-step processes for lots of different styles that you can easily execute yourself. And we won't have you buy a bunch of fancy supplies either . . . just the basics to get you on your way without breaking the bank. Feel free to follow the steps exactly *cough*perfectionist*cough* or make it your own. Have no fear: This isn't like getting a tattoo that lasts forever. Worst-case scenario? You can wait for the wall to dry and paint over it!

ECO-CONSCIOUS PRACTICES

Painting murals can be a very wasteful activity if you're not conscious of your supplies. In the projects throughout the book, we used leftover paints from previous projects and, whenever possible, reused supplies.

If you want to do your part to not be wasteful, there are a couple options for you. Every paint store has an "oops section" for paint that was mixed to be the wrong color. You often can find some great colors in this section, and because that paint otherwise might go to waste, most of the time it's heavily discounted, so extra bonus! In addition, try to buy reusable supplies—like fabric drop cloths instead of disposable plastic drop cloths.

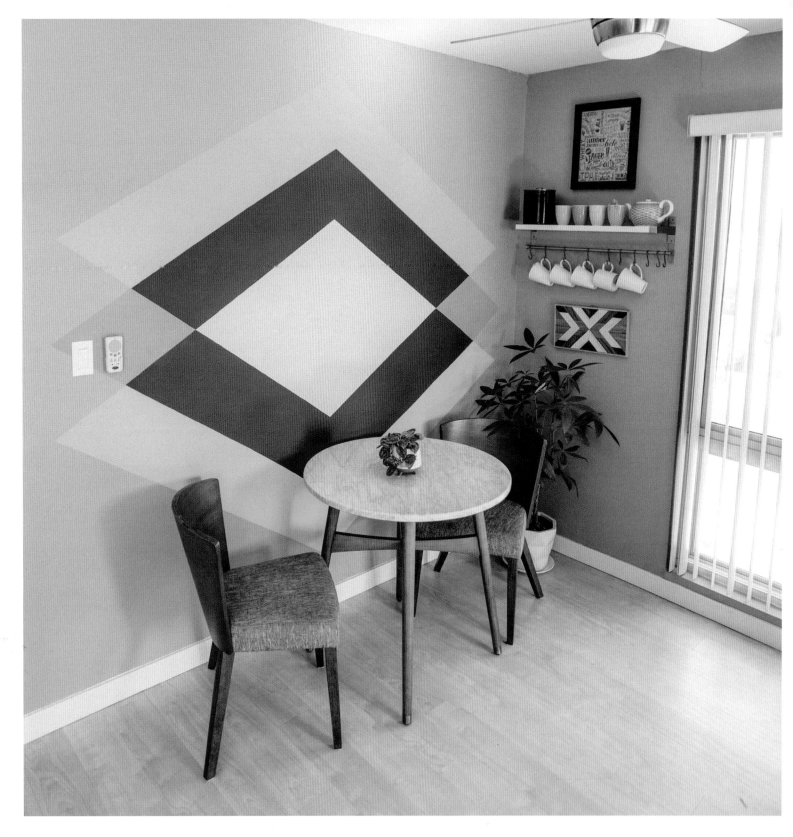

CREATING YOUR SPACE

Some home DIY projects require a ton of prep work, money, and time. But paint is much more affordable than wallpaper or tile, and painting a mural is an inexpensive and flexible home renovation project.

Whether you think you're a creative person or not . . . you are. Everyone is creative! By simply making little decisions, like the colors and location of your mural, you're customizing your paint job. There is no certificate or diploma for painting murals. It's not brain surgery. You are in charge and you can have fun! Don't let anyone tell you differently.

Painting can also be really therapeutic. Throw on some comfy clothes you don't mind getting paint on, blast your favorite music or podcast, and get to work. Chances are you'll zone out, and before you know it hours will have passed. It's so easy to get lost in the work. When you're done, you'll be so satisfied.

Just imagine when your friends or family come over and see your new mural; they're going to ask who you hired to paint it. And you'll get to say with confidence (and a sense of accomplishment), "Oh that? I did it myself!" *hair flip* Cheers to that!

Some of you might be thinking that your landlord won't be cool with you adding your own paint job to your space. But don't worry—you're not going to damage the wall. You can explain to your landlord that you can always paint the wall back to the original color before you move out. So get permission (or, if you're a real risk-taker, ask for forgiveness) and get painting!

We have a passion for transforming spaces, and we're excited to help you learn to do the same. We hope you get as excited as we do. You can certainly get creative and have fun with paint.

Phoebe + Roxy

First Things First

CHAPTER ONE

There's probably a lot running through your head. Don't panic! We will help you figure out this mural-painting thing. Again, it's not brain surgery. It's not rocket science. Nobody is going to die (hopefully) if you put the "wrong" color of paint on the wall. But there are a few things to consider before you start painting. So slow down, take a look around, and ask yourself the following questions:

- Do I want a touch of color or a bold statement?

- Do I want an accent design, or will this mural be the central focus of the room?

- What is my furniture like? Are the colors neutral? Is the style modernist?

APPROACH THE SPACE

What's great about painting murals is that you can customize everything to fit the needs of your home. Even if you rent, you "own" the space. Don't let the space own you.

But seriously . . . each wall and each room has its own setup, which leaves lots of room for opportunity. For example, what kind of lighting is there where you want to paint? Maybe there's natural light. Or maybe there aren't any windows. If your space is dark, consider using lighter colors (such as pink, lavender, bright yellow, or powder blue) to brighten it up. If your space is small and you want to make it feel bigger, sometimes dark colors can do the trick! Dark colors absorb more light than light colors do, blurring the edges of the room and making your space feel larger than it really is.

How about the ceiling height? Do you have a lot of furniture and/or knickknacks crowding the walls? These are all important to consider when choosing your wall design. From the color scheme to layout to sizing, you can customize each design aspect for your room and your new wall painting will tie it all together.

Choose Color

Don't stress out about choosing color. This is the fun part! Still, when making this kind of decision, there are quite a few things to consider, including lighting, furniture, flooring, windows, what kind of mood you're trying to set, and what colors go together. Think of it like picking out an outfit: You want to make sure your top, bottoms, and shoes work together. And then you might add in some statement earrings or a hat to give it some extra flair.

The first question to ask yourself is whether you want your mural to be the jeans that look good with everything because they're not too overpowering or the statement jewelry that elevates the whole look. That is up to you to decide!

Next, consider what colors are already present in the space. Look at the furniture, flooring, curtains, pillows, etc., to see what color story currently exists. Choose colors for your mural that will be cohesive with the colors that are present already. To do this, let's consult our handy-dandy color wheel.

This little guy holds all of life's answers! Well, not really, but the color wheel is very helpful when picking your color palette.

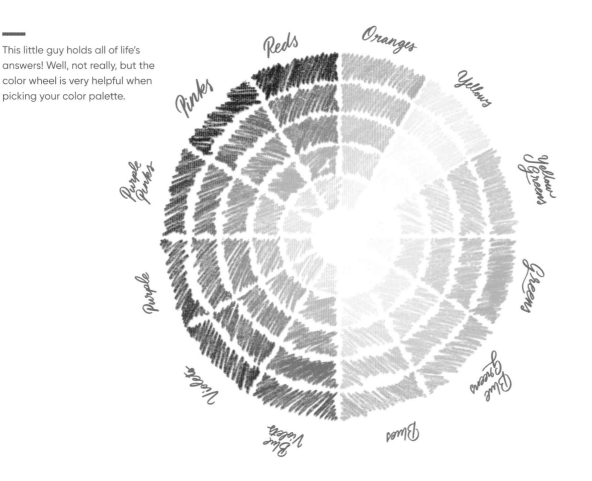

There are a few different options when picking colors that go together. If you're new to color or feel intimidated by choosing colors, we recommend starting with a monochromatic color palette. If you have a bit of color confidence already, you may want to choose color combinations that complement or contrast with one another. But even if you go that route, we recommend sticking to three colors maximum in your murals. The more colors you use, the quicker things can go awry.

Let's start with the easier method: sticking to one color family. Monochrome is sexy! Shades and tones of one color are a winner every time. So if you already have a blue rug and blue curtains, pull in some light tones of blue and dark shades of blue to match and make it a vibe.

Our Triangle Headboard (page 124) uses two shades of pink to create a sophisticated look.

If you're a little more daring, try working with colors that are directly across from each other on the color wheel. Opposites really do attract! (In color theory, colors directly across the color wheel are known as complementary colors. Don't ask us why. It's science!) So think purples and yellows or oranges and blues. Mix and match lights and darks of complementary colors for a lovely and sophisticated look that any interior designer would give you props for.

The orange and blue in our Ocean Scene (page 76) are a bold example of using complementary colors.

TONE IT IN

Let's get technical about shades, tints, and tones. Believe it or not, they mean different things!

A *tint* is created by mixing white into a pure color. These are the softer colors; think pastels.

A *tone* is created by mixing gray into a pure color. These are a little moody, less vibrant. Think earth tones.

A *shade* is created by mixing black (sparingly— a little bit goes a long way) into a pure color. These can be rich, dark colors.

And that's your color theory lesson for the day!

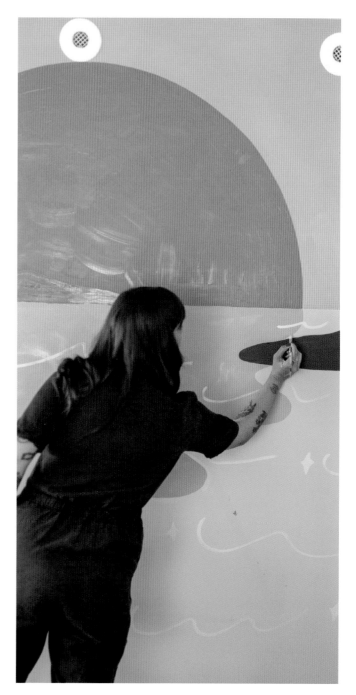

If you're a real color addict and need more than two colors in your life, we have two options for you. You can either pick any three colors that are next to each other on the color wheel, making one the dominant color in your design and leaving the other two colors for accents. Or you can pick a triadic color scheme, which gives you a little more versatility and is an overall bolder look.

We know what you're thinking: "Roxy and Phoebe, what the heck is a triadic color scheme?!" We'll tell you! A triadic color scheme uses three colors that are evenly spaced around the wheel, making a triangle shape between them. Again, pick one to be the dominant color and use the other two for accents.

If you're not ready to commit to a color scheme just yet, buy some color samples and paint a few patches on the wall. Live with them for a few days to see if you're in love or not.

Finally, if you're still totally overwhelmed and can't decide on colors, there are some great online quizzes that will tell you what color your soul is! Paint your wall that color.

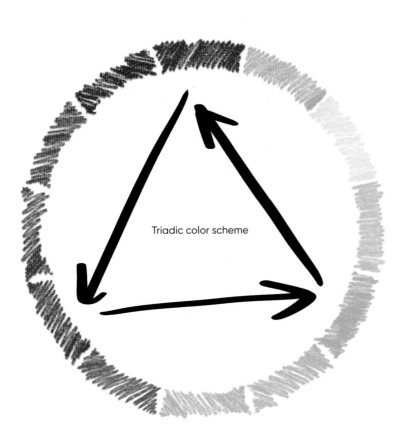

Triadic color scheme

LUSTROUS

Not to overwhelm you too much, but paint sheen is a thing, too. It ranges from high gloss to flat. We're total flat sheen girls. We don't like a glossy look, but hey, if that's your thing we won't judge you. Typically, semi-gloss is used in kitchens and bathrooms, since it's easier to clean, while flat is used everywhere else. Whatever kind of sheen you like, make sure you stick to one per wall.

Consider Your Light

Lighting can drastically change the way colors look on your walls. Seriously! Some LED bulbs (the basic bulbs today that are probably in all of your lamps) give off a warm light, which makes oranges and reds look more vibrant and dulls down cool colors. Higher temperature LED bulbs and fluorescent lights give off cooler light, which makes blues and greens look brighter and reds and oranges look duller.

Depending on which direction your windows face and how much sunlight you get, the lighting on the wall can change throughout the day, too. To avoid a total color disaster, paint some sample patches on your wall and observe not only how the colors change over the course of the day but also how they look at night with the lights on. You might be surprised at how much the effect changes.

START YOUR DESIGN

To help you figure out what kind of design you want to paint on your wall, make a mood board. Start by collecting images that you like from Pinterest, magazines, and books (including this one!). Find images of rooms that have similar lighting and furniture as yours, and see what kind of wall painting you like in those settings. Will palm leaves on the wall look great with a plaid couch? Maybe, or maybe not. It depends whether you're good at power clashing.

Once you have found some designs that you like, think about how you use the room you're going to paint. Are your kids likely to rub their cute, dirty hands all over the wall? If you're investing the time and money in painting a mural, your design should look cool but also be functional and smart.

Feel free to paint a sample section of your wall first. You don't have to paint the entire wall blue to figure out that you hate the color blue. Painting a sample is pretty affordable and is much easier than trying to return multiple gallons of paint.

Sketch It

Sketching a design before you start working on the actual wall will not only help you execute the final painting better, it will also let you see if the design even fits in with the space. The sketch will give you the opportunity to think about a few options before committing the time and effort to painting a wall.

By sketching on a photo of the wall, you'll be able to consider your surroundings more concretely. Do you need to integrate the TV or bookshelf into the mural? What sort of shapes would match the pillows on your couch? Try stripes, an arch, or a flower. Test out the proportions and sizing of your design as well. You'll be especially grateful if your sketch helps you realize that your planned design won't work.

Several apps allow you to draw right on top of photos. If you have a smartphone or tablet, you can take a picture of your wall and then sketch mural ideas directly on top of the photo to see what works. We use a program called Procreate for this.

If you don't have access to a smartphone or tablet, try sketching the old-fashioned way. Print out a picture of your wall (or maybe a couple, because no one's design is perfect on the first try) and use a pencil to sketch out the design you're thinking of. Your sketch doesn't have to be perfect, so don't be too hard on yourself! This exercise is just to get the ideas flowing and to gain a sense of what the mural is going to look like on the wall.

Once you practice a few ideas and like what you see, take a second to bask in your own amazingness. It can feel vulnerable to create art, especially if it's not something you do every day. We're proud of you!

Must Have

With your sketch in hand, it's time to think about what materials you'll need to paint your wall. Each project in this book lists exactly what supplies (and how much) you need. Here we give you an overview of the items you'll use most often. We generally purchase supplies from our local hardware store, but you can also purchase most of these online.

PAINT

Let's talk about it! The majority of interior paint you'll be dealing with is latex based, a.k.a. water based. It's the most common and environmentally responsible paint option. Oil-based paint exists, but we don't recommend using it unless the surface you'll be painting needs to be super durable and you don't plan on painting it often. Oil-based paints are much more difficult to paint over and should only really be used for permanent solutions.

Fun fact: You can use exterior paint indoors. You can't use interior paint outdoors, though, because it doesn't have the qualities that protect it from the weather and sun. If you're doing a lot of projects both indoors and outdoors, we recommend buying only exterior paint. However, it will produce more of a smell, so make sure you have your windows open!

Paint sheen determines how shiny or flat the dried surface will look. It's important to choose the right sheen for the job, and there are a few options. The most common sheens are flat, eggshell, satin, semi-gloss, and gloss. The more sheen a wall has, the easier it will be to wipe clean, which is why semi-gloss is most often used in high-traffic areas like bathrooms and kitchens and gloss is used on trim. We tend to be flat gals, but you'll have to choose your favorite!

One gallon of paint can cover about 400 square feet, so it should be enough for a couple coats in a small room. There are four quarts in a gallon; therefore one quart of paint will only cover about 100 square feet. If you don't need much of a color, we recommend purchasing a quart or even a sample size.

BRUSHES

It's good to have a range of brushes on hand when you're painting a mural. The size of the brushes you need are directly related to the size of the area you're painting: Use small brushes for tiny details and large brushes for filling in large areas. If you use a small brush to fill in a large area, you'll regret it!

It's best to have at least one or two brushes for each color you're using. If you don't know what brush sizes you need, buy a variety pack. Most hardware stores carry sets that include 1-inch, 2-inch, and 2½-inch brushes. If you are a perfectionist, also pick up a pack of tiny brushes for touch-ups.

We recommend using brushes with wooden handles because they are higher quality and last longer than brushes with plastic handles. Good wooden-handled brushes also make it easier to paint a straight line.

In addition to the brushes themselves, you will need a bucket of water and either a plastic bag or plastic wrap. When you're using a brush but want to swap to a different color, instead of washing the brush out (or letting it sit in the open and dry out), wrap it in plastic. This will keep the bristles saturated and ready to paint. When you're finished using a brush, put it in the bucket of water for a few hours until you're ready to clean up.

Cleaning brushes is no fun, but it's part of the process. If you're finished using a brush but are still painting, keep your used brush(es) in a water bucket so they don't dry out and get ruined. When you are finished painting, use warm water and soap to get all the paint off the brushes, then set them out to dry.

If your brushes do dry out with paint still caked on, don't worry! You can repurpose them for creative decor ideas. We've kept dead brushes in a vase for a pop of color, made a holiday wreath with them, and hung them as ornaments.

ROLLERS AND TRAYS

Rollers are useful for filling in large areas of color. You can work without a roller and use only a brush, but it will take a lot longer. If you decide to use a roller, you'll need to have a roller frame, roller cover, paint tray, and, in some cases, an extender. The roller frames, paint trays, and extenders are reusable, which is great if you're working on multiple mural projects.

Roller frames and covers come in a variety of sizes. We recommend using 9-inch rollers for large areas and 4-inch rollers for smaller areas. The frames range from basic to expensive. Basic plastic frames get the job done just fine. But if you are going to roll a huge wall (or a lot of walls), we recommend you invest in high-end rollers with cushy handles, which help prevent your hands from getting sore.

Roller covers vary by fluffiness (or in technical terms, nap). Choose your nap based on the texture of the surface you're painting: The rougher the texture of the wall, the fluffier the cover should be to ensure paint gets in all the cracks and crevices. For a basic drywall surface, which should be pretty smooth, you could use a roller with a ⅜-inch nap. But for something like stucco or brick, which is not very flat, you should use a roller with a ¾-inch nap. Depending on how many colors you're using or how many days you're painting, you may need a few roller covers since they don't work very well after being washed out, and if you don't wash them they'll dry covered in paint.

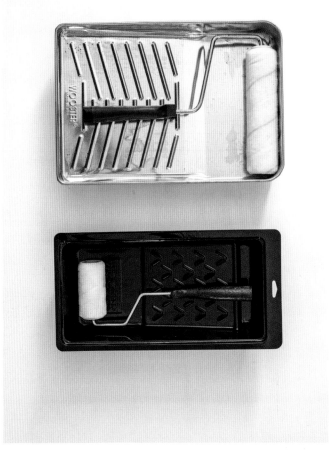

Trays come in different sizes to match the length of the roller frame you are using. We recommend using metal roller trays because they are reusable. You can either put a plastic paint tray liner in the metal tray and then toss the liner when you're done, or wait for the paint to dry and then peel it out of the metal tray to reuse the tray.

If you need to roll an especially tall wall, an extender (shown on page 37) will be very helpful. Simply screw the extender onto the bottom of your roller.

How to Choose

PAINT

When you're starting a project and heading to the hardware store to pick out your paint, you'll need to consider a few different things. What kind of surface will you be working on? Is it stucco, drywall, wood, metal? Will you be repainting it or needing to touch it up often? How much contact will it have with everyday life? Let's be honest with ourselves here: Your mailbox is going to see a lot more wear and tear than your living room ceiling.

It's likely that whoever is working behind the paint counter at the store will be able to advise you on what would work best for your project, but it's also good to know these things for yourself! If you're painting something that lives outside, it's best to use exterior paint. It's made to be more durable and withstand the elements. You can use exterior paint inside, too, but the chemicals in exterior paint can be pretty strong smelling, so consider ventilation before using it indoors.

When it comes to sheen, you should consider what kind of wear and tear the wall (or item) will receive.

Generally, the shinier the sheen, the more stain-resistant it will be. This is why semi-gloss and gloss paints are typically used for kitchens, bathrooms, and other places that need to be cleaned often.

Finally, you'll need to consider whether you want latex (water-based) or oil-based paint. You'll almost always want to use water-based paint because it's more flexible and easier to clean up. However, if you're looking for something incredibly durable that adheres to most surfaces, use oil-based paint. You can't use oil-based paint over water- or latex-based paint, but you can use water-based paint over oil-based paint. If you're not sure what kind of paint is already on the wall you want to paint, wipe the surface with denatured alcohol. If the paint comes off the wall, it's water based; if it doesn't, it's probably oil based.

Every paint brand likes to claim it's the best of the best. We have yet to be convinced by any single brand, regardless of whether it is low grade or

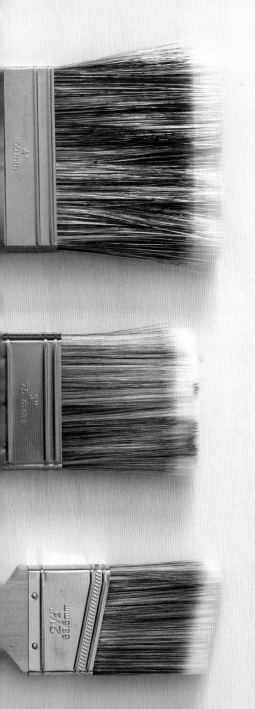

high grade. Any paint that you can find at your local paint stores will work well. Our favorites include Dunn-Edwards, Behr, Sherwin-Williams, and Valspar.

No matter what color you use, you're almost always guaranteed to have to paint more than one coat. Applying a single coat of a color would be the absolute dream, but it's always safer to do multiple coats, especially in locations where the lighting changes dramatically throughout the day. Additionally, the specific paint color often dictates how many coats you'll need. Whites, yellows, and reds are notorious for being see-through. This has something to do with the pigments used in the manufacturing process (it's science, people!). So if you want to use fewer coats of paint, try to avoid those colors in your design.

At most hardware stores you can get sample sizes of paint, which are worth purchasing before buying multiple gallons of a color. Samples are a cost-effective way to see how the paint will look on your wall. Trade secret: The term "sample size" is very loose. At some stores the samples are quite big. Sometimes we even use sample sizes rather than buying quarts of paint. Shhh! (Paint samples are often a lot cheaper than quarts, so why not?!)

BRUSHES

The wider the brush, the more wall space it will cover. It's nice to have a variety of brush sizes in your tool kit. Choose your brush based on the size of what you're painting. If you'll be working on a small and ornate flower, it wouldn't make sense to use an 8-inch-wide brush. And for large spaces (like an entire wall), it makes sense to use a roller instead of a brush. This will save you a lot of time.

Both hardware stores and craft stores offer great brush options. We prefer brushes with wooden handles because they are higher quality and tend to last longer than brushes with plastic handles. In addition, after the brush is cleaned, less water drips from wooden handles than from plastic handles.

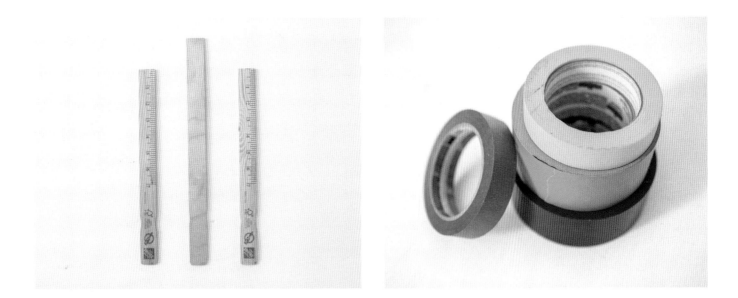

STIR STICKS

When paint sits for a few days,* the colors start to separate and you'll need to mix it up before you begin painting. Stir sticks are handy to have around for just this purpose. The best part about stir sticks? They're free! Most paint suppliers will give you some stir sticks when you get your paint mixed, but if you don't see any, just ask your paint pro for some.

*NOTE: If paint has been sitting around for a few years, smells funky when you open it, and won't mix no matter how long you stir . . . get rid of it. It's past expiration and you should dispose of it properly. Most cities have paint recycling and disposing drop-off centers. Look online to find the proper drop-off location where you live.

TAPE

Painter's tape is used to mask off certain areas while you paint. It comes in a variety of weights and sizes, including 1-inch and 2-inch widths. Thinner widths are good for helping you create curves and details in your work, or when you need to paint tricky areas. Use thicker tape for protection along the edges of your wall and anything you don't want to get paint on, including trim and door hinges.

It is important to use tape that is made specifically for painting. Green FrogTape and blue painter's tape are both good for normal, everyday projects on drywall or wood. If you're painting on a more difficult surface, such as brick, stucco, or cinder block, it's best to use a heavier-duty material called stucco tape. It's not fun to work with (because it is so sticky), but it really gets the job done.

DROP CLOTH

There are basically three options when it comes to drop cloths: canvas, plastic, and paper.

CANVAS drop cloths typically come in 9 × 12-foot sheets, so they extend the length of most interior home walls. They are reusable, easy to pop in the washing machine, and last a long time. If you're going to be painting several murals, we suggest getting one or two canvas drop cloths.

PLASTIC is great to use if you have to travel to a work site or if you are painting only one mural. You can tape the plastic to the edge of your wall so you get total coverage. Plastic drop cloths will start breaking down if you use them over and over, but they are great for single use.

PAPER drop cloths are made from thick craft paper. Paper works well if you need to cover large exterior spaces, especially if your project will last more than one day. You can tape the paper directly to the ground and leave it in place while you complete your mural. Paper for this purpose generally comes in 150-foot rolls, so it is best for larger murals.

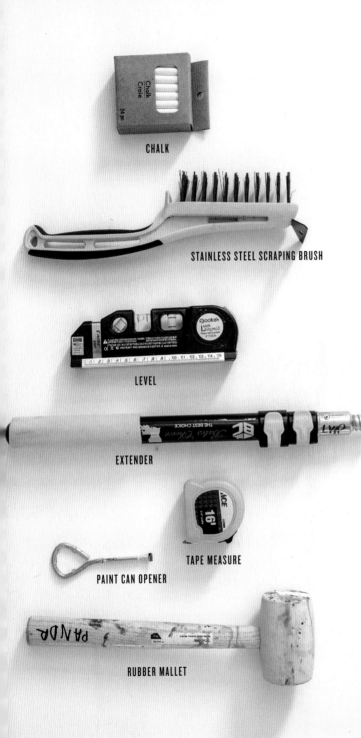

CHALK

STAINLESS STEEL SCRAPING BRUSH

LEVEL

EXTENDER

TAPE MEASURE

PAINT CAN OPENER

RUBBER MALLET

MISCELLANEOUS TOOLS

CHALK. Use white chalk to draw your design on a wall that isn't white. If you mess up, just grab a wet washcloth and wipe off the chalk. We love chalk because it's so impermanent. Avoid using colored chalk on your walls, though, as it will stain the wall and doesn't fully come off.

CUPS. Instead of carrying a heavy gallon of paint up and down a ladder, try using paint cups. The handle makes them easier and more comfortable to carry.

LEVEL. There are few things worse than spending the time and effort to install a mural and then stepping back and realizing it looks crooked. Measure and level first, *before* you start painting. It will save you a lot of headache.

PAINT CAN OPENER. This little tool is also free. When you order paint, ask them to throw in a paint can opener as well. We both keep a paint can opener on our key chains, so we always have one with us. In a pinch you can use a flathead screwdriver, keys, or, in a real emergency, a quarter!

RUBBER MALLET. Raise your hand if you've ever spilled a gallon of paint in your car! Hint: Both of our hands are raised. That messy problem can be eliminated by simply securing your paint lids when you're done with them. Use a rubber mallet to do this. (Trust us. You do not want to be stuck on the side of the road at midnight and have to tell the tow-truck driver your spare tire may or may not be painted blue. True story!)

STAINLESS STEEL SCRAPING BRUSH. You should only need to use this in emergencies, when you spill paint where you're not supposed to, especially in outdoor areas with cement or asphalt surfaces.

TAPE MEASURE. This little tool goes a long way. Seriously: Most go between 16 and 50 feet! Always keep a tape measure in your tool kit.

CHAPTER THREE

Let's Get Painting

You have your design and your tools. Now the fun begins! You're finally ready to start painting. It's going to be wonderful.

WALL PAINTING 101

We know it can seem scary and intimidating to cover a big surface like a wall in paint, but don't worry—it will be okay! With the right tools and following our step-by-step instructions, you'll nail it. Worst-case scenario, if you hate your mural, wait for it to dry and paint over it. No big deal.

Prepping Your Wall

Start by covering everything in the vicinity that you don't want to get paint on. Like we said, painting can be a messy process, and paint can be hard to get off places you don't want it to be. So tape off the wall edges—including at the floor and ceiling—and anything else touching the wall that you want to remain paint-free. Move any furniture you can so you have enough space to work. Cover with your drop cloth(s) the ground and any furniture that you can't move. Remember: Plastic drop cloths are a lot cheaper than reupholstering a couch or getting it professionally cleaned.

Now take a look at the wall itself. Are there any cracks, holes, dry paint drips, or imperfections? Use spackling and a putty knife to fill in holes or cracks to give yourself a nice, neat canvas to work with. If there are any dry paint globs, use a piece of sandpaper to get a level surface.

Make sure you're wearing clothes that you don't mind getting paint on.

And finally . . . you're ready to get painting!

Wall Priming (or Not)

You (mostly) don't have to worry about primer. Woo-hoo! Most paints these days (in the brands we recommend on page 34) have primer blended right in. Think of them like 2-in-1 shampoo and conditioner; they'll save you lots of time.

There are a few rare cases, though, when you will need to prime your walls. For instance, if your wall has never had any paint on it, like never ever (think raw brick, wood, and bare drywall), you should prime it. Or if you're going to paint a light color over a dark color, prime the wall to make sure your new colors really pop!

Side note: If you're painting furniture, you may need to prime it first. We talk more about painting furniture on page 47.

Applying Paint to the Wall

Start by taping off the edges of the wall or the edges of the area(s) you will paint. If you want to get the most detailed work out of the way first, outline the edges of the taped area with a small or medium-size brush. Sometimes we instead like to start by filling the inside part of the wall with a roller. As we noted earlier, a roller will be a major time-saver if you're painting large areas. You're also more likely to get an even covering with a roller than you are with a brush. If you want your wall to have more texture or if the unpainted area is relatively small, use a brush. (And read on!) Whenever you use a brush, make sure it is decently coated, but not dripping paint everywhere. We recommend using nice, even strokes.

WALL SURFACES

Are your walls made of plaster? Drywall? Wood paneling? Brick? The texture of your wall will dictate the length of your project. It is going to take you a lot longer to finish a mural on raw brick than on smooth drywall. Because raw brick sucks up all the paint, you can expect to do quite a few coats on this surface. Wood can be tricky, too, as it also absorbs a lot of paint if it hasn't been coated with something already.

CREATING TEXTURE

Adding texture in your mural will make the wall look 3D without actually being 3D. However, you do not want to leave an actual mountain of paint on your wall. Instead, you'll use sponges, various size brushes, and different roller heads. Old washcloths and rags can work, too, if you're going for a messier look. Feel free to get creative with your materials.

Each of these tools applies paint in different ways. The paint will not glide onto the wall like a solid blanket. Instead, you will create depth by combining the base color with whatever color you are applying. The Sponge Brush Pattern (page 110) and Cotton Candy Watercolor (page 162) projects both incorporate texture into the design.

IDEAS FOR NONTRADITIONAL SPOTS

In a perfect world, every wall would be perfectly flat, well-lit, and easy to paint, but that just isn't reality. We know some of you may have some tricky spots you want to paint, and that's great! We love a challenge, don't you? In fact, an unusually shaped or textured wall—and even an odd-sized wall that you don't know what to do with—could be the perfect place to apply some paint. Let's explore some of the common tricky spots and figure out what to do with them.

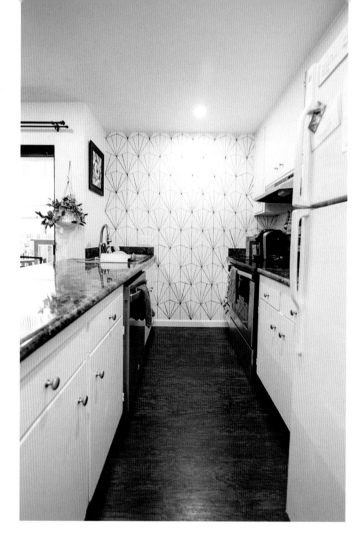

How Do I Make a Dark Kitchen Look Brighter?

Lighter colors—especially gold, silver, and white—reflect light and are a great way to help brighten a kitchen. Painting wooden cabinets is also a good way to make a kitchen look lighter. Cabinets often take up the majority of a kitchen, so if you're able to paint them a lighter color, go for it!

How Do I Make a Small Bedroom Seem Bigger?

Interior designers use a trick with curtains to make rooms seem larger: If you place curtains higher up above the window, they draw the eye upward, which makes the room seem bigger. We want to do the same with paint. Place a pattern or part of the mural up at the top of the wall, and your eye will follow it up. Lighter colors also help make a room seem bigger. Try to avoid painting dark tones and shades in a small room with little light; doing so will make the room feel even smaller.

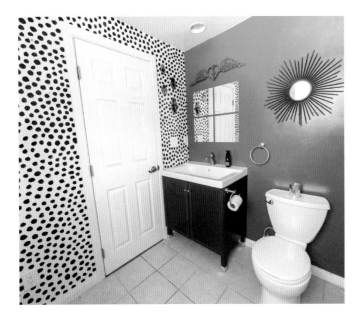

How Do I Make a Bathroom Fun?

Who doesn't love showering in the jungle? Palm leaves and animal prints are a great way to spruce up a bathroom. Both shapes are pretty organic and don't need to be perfect, so feel free to get a little "wild" with it. Most bathrooms have showers, mirrors, vanities, and toilets to work around, and the organic shapes allow your design to be a bit playful and are less restrictive than, say, a chevron pattern.

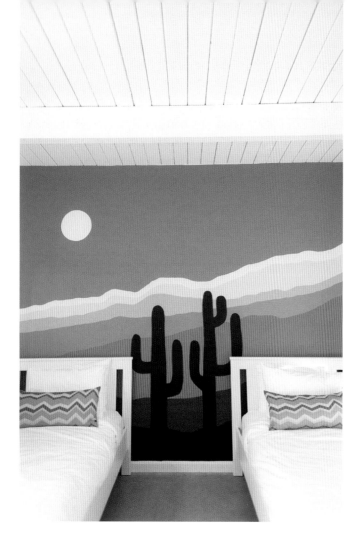

Can I Paint the Ceiling or the Floor?

Yes! Do it. Murals don't belong only on your surrounding walls. Having a mural bleed onto the floor or ceiling can add some extra spice. In the Painterly Ceiling mural (page 136) we show you how to paint a ceiling, but if you're feeling really ambitious, you can apply any of the other projects to a ceiling or even to a floor.

But be warned: When you're painting the ceiling, make sure to take some extra breaks because your neck is definitely going to feel it! The ceiling we painted was standard drywall, so we used regular interior latex paint. If your ceiling is a different type of material, check with your local paint professional about what kind of paint will work best. For the floor, use extra-durable paint, and seal it afterward with a clear coat.

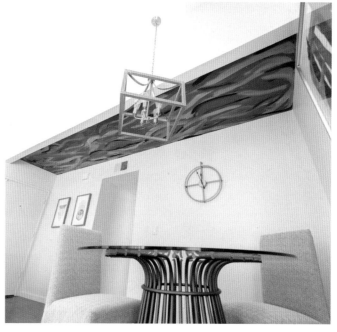

What Do I Do with a Windowless Room?

A wall physically boxes us into a space, but paint can easily undo this. Your job is to trick the eye. Gradients and a watercolor technique can definitely help with this. Or you can paint clouds, an ocean scene, or a constellation! Anything that makes you think you're in a different space will help.

How about My Furniture?

Painting furniture is a fun and easy way to transform your room. If you paint furniture, though, we recommend you stick with wood because plastic, metal, and any sort of composite may react differently to your typical interior or exterior house paint. Spray paint will help you get a smooth and even finish and is especially helpful on pieces with hard-to-reach areas. (Be sure to practice on a scrap piece first and avoid spraying in dusty or windy conditions.) No matter what kind of paint you use, it's crucial that you use painter's tape to protect the parts of the furniture that you don't want painted. You can also use tape to create designs such as stripes or other geometric shapes.

Troubleshooting

Just like with everything in life, things happen when you paint murals. Sometimes you paint a wall and then a week later decide you hate it. Or you wish you had painted a different wall. That's okay. Nothing with paint is permanent. There are ways to fix every situation you might get yourself into!

WALLPAPER

If the wall you want to paint has wallpaper on it, you should remove it before painting. Depending on how old the wallpaper is, it can be kind of tricky to remove. But it's not impossible! Some types of wallpaper can be stripped dry, but some can only be stripped using a removal solution. You can purchase wallpaper removal solution at your local hardware store or search online for a recipe you can make at home. Once you apply the solution to the wall, slowly start pulling off a corner of the wallpaper. If you can't easily peel up a corner of the paper, apply some additional removal solution and let it soak in. Then use a putty knife to help pull back the paper. Work slowly and patiently; removing wallpaper is an art form in itself!

If you need a removal solution to strip your wallpaper, put down drop cloths and remove all outlet covers before getting to work.

UNEVEN PLASTER

Almost every plaster wall in the world is uneven. Let the space guide your design. If your wall is super bumpy, try to design something abstract for your mural. (A design with a lot of straight lines will look crooked or, more generally "off," if it's painted on an uneven wall.) A roller with a thick nap (height) will give you more coverage on an uneven surface. If you're using a brush instead of a roller, expect to paint a few more coats than you normally would on a smooth surface.

TIRED OF YOUR MURAL?

Paint over it! That is why we love paint so much. No mural has to be permanent, and it's easy to create something new. The hardest part is figuring out what your new mural will be. Once you decide on your new design, follow these steps to ensure your new mural looks great:

- If there is existing texture from the paint strokes of your current mural, use a light sandpaper to even out the paint. Don't sand too hard, especially if you're working on drywall.

- If the wall is already painted a dark color and you want to paint it light, you may need to do more coats than normal. Paint with primer will be especially helpful in this situation. Be patient!

TECHNIQUE TOOLBOX

Hopefully you've gotten the picture by now that you have lots of possibilities when it comes to wall painting! Here are some of the techniques that we will walk you through in the next chapters. Remember that any of these approaches can be customized with colors and sizing to fit your home, so use your imagination to figure out what will work best for you.

Geometric

Take your straight edges to the next level and create something super complex. We recommend using a lot of tape if you're going to paint geometric shapes. See pages 104, 114, 124, 152, and 166.

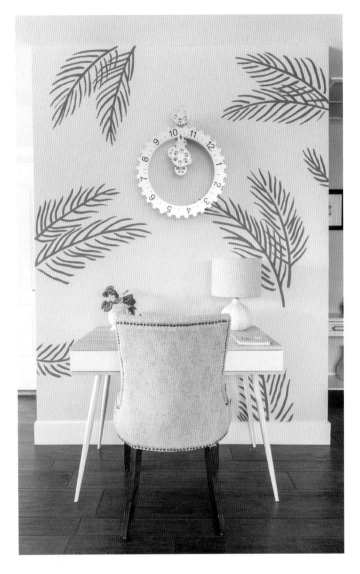

Ombré

There's something about a gradient that is incredibly relaxing. Perhaps it reminds us of a sunset or the ocean. This technique is a relatively easy way to add multiple colors to a room without being overpowering. See page 62.

Leaves and Flowers

If you're a serial plant killer, this is a great way to add some nature to your space without having to worry about watering! See pages 66, 98, 120, and 130.

Color Blocking

Painting only half your wall creates a whole lot of interest! For this technique, you need to remember one thing: tape, tape, tape! It's your best friend. Make sure to smooth out the tape with a credit card or gift card so that your lines are extra crisp. See pages 92 and 152.

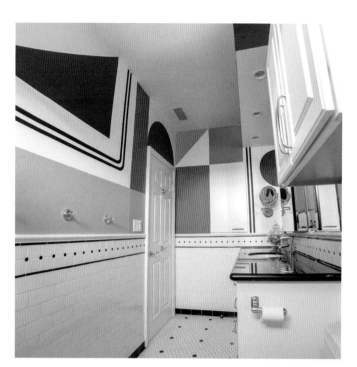

Lettering

Do you have a mantra or phrase that makes you happy? Paint it on your wall and keep the inspiration flowing. See page 98.

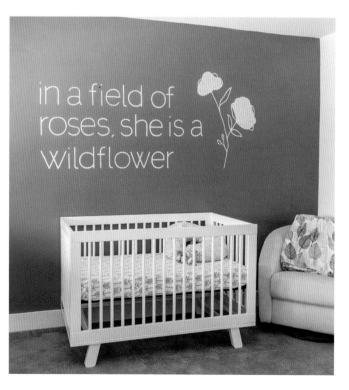

Projection

Using a projector is a great way to create a more complicated design in your mural without worrying about free handing it on the wall. We have downloads to make it super easy for you! See pages 98 and 130.

Painterly

Create a dreamy watercolory wall that makes you feel at peace. With only a few shades of a color and the blending technique we describe on page 164, you can create this effect with ease. It's a perfect look for a bedroom, office wall, or even your living room.

Faux Tile

Giving your ruler and level a good workout allows you to create repetition in your space without breaking a sweat. See page 146.

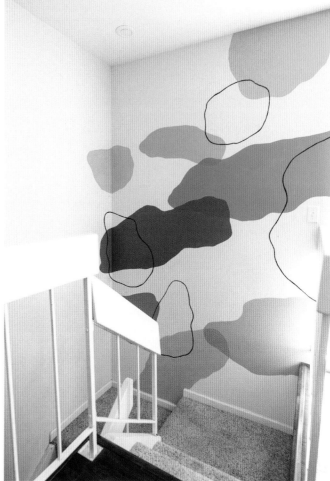

Overlays

Overlays look way trickier than they are. You will fool the viewer into thinking you spent hours painting! See page 82.

Nature Inspired

Whether you're a desert person or more of a beachgoer, we have a couple options for you. Bring the outdoors inside with a nature-inspired mural. See pages 76 and 156.

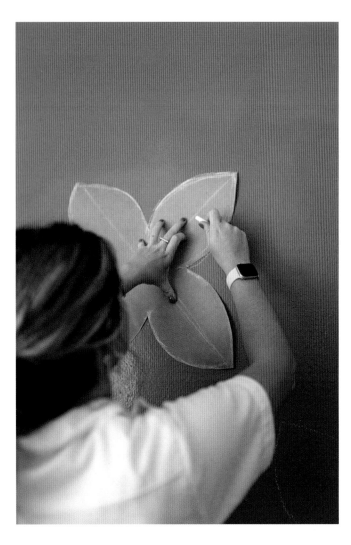

Sponge Brushes

Sponges aren't just for the bath. Use them to create some depth and texture on your wall. See page 110.

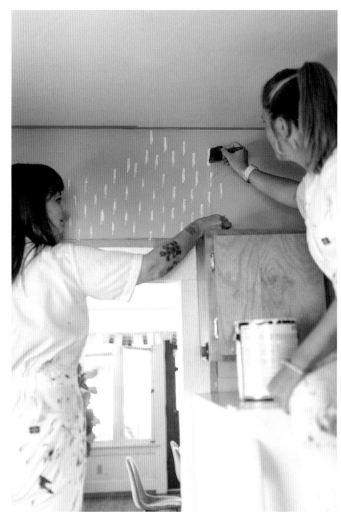

Chalk Tracing

We'll show you how to use chalk and a printout to make your paint job totally perfect. See page 120.

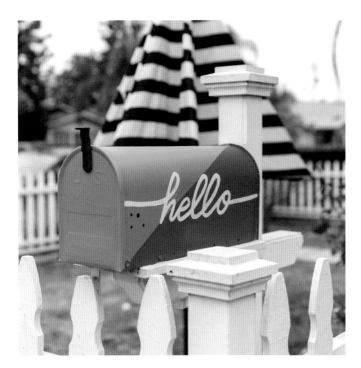

Mailbox Painting

We love a good mailbox mural! Life is too short to have a boring gray or white mailbox. Show the neighborhood that you're the cool kid on the block. Because a mailbox has only a small amount of surface area, don't try to do anything too detailed. See page 182.

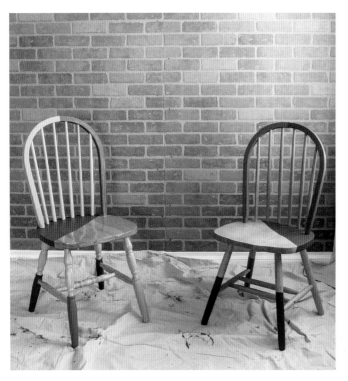

Furniture Upgrade

Who says paint is only for walls? We'll show you how to create an interesting look on a couple different household objects. See pages 186, 190, and 196.

Wall to Wall Projects

If you've made it this far, you are ready to check out the fun stuff! In this chapter we curate 22 projects in various homes to give you an idea of the possibilities that you can create on the wall with paint. Each step-by-step guide shows you exactly how to replicate the design on your own wall. But don't feel limited by the colors we used; get creative! It's all about making something completely custom for your space. This is your opportunity to really create some wonder on your walls!

Sunset Ombré

BEFORE

A fireplace is a perfect place for a showstopping mural moment. When we first saw this fireplace, it was white and boring, and we wanted to create something to celebrate it! We decided on a pastel ombré look to avoid overpowering the space. If you're not a pink person, don't let these colors scare you. Feel free to use some blues or greens, or even make your ombré fade from white to black. It's your space and your call.

Oh, and if you don't have a fireplace, no worries! You can use this technique on any wall or even on a piece of furniture.

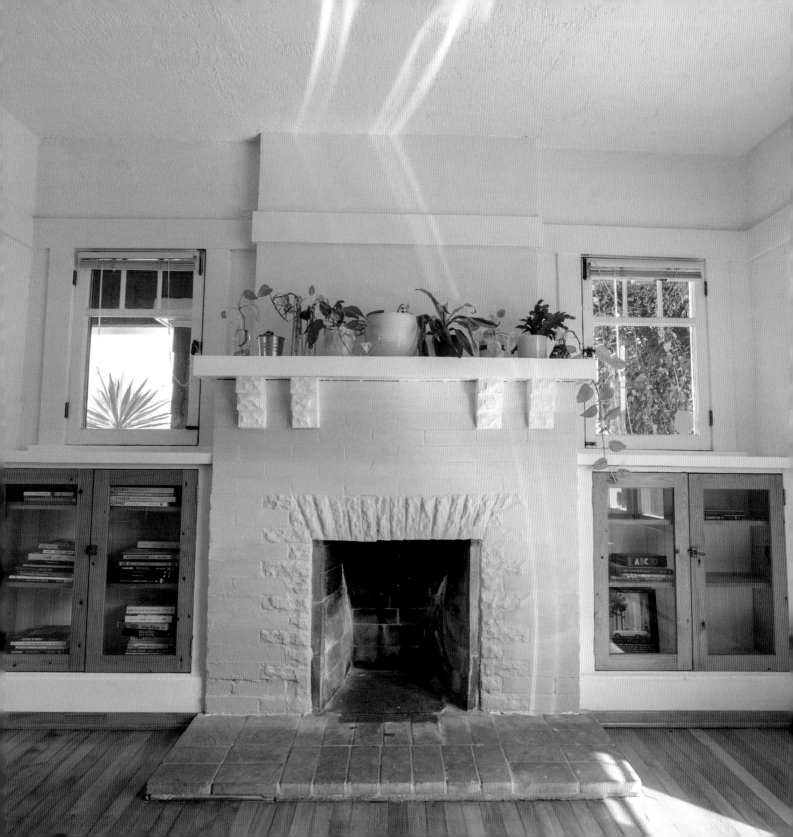

TOOLS

- [] 1 drop cloth
- [] 3–5 medium-to-large brushes
- [] Used coffee/soda cup for mixing colors
- [] Step stool or ladder

MATERIALS

- [] 1 roll painter's tape
- [] Pencil
- [] 1 quart white paint
- [] 1 quart golden yellow paint
- [] 1 quart coral paint
- [] 1 quart bright pink paint

PREPPING

Clear anything out of your workspace that you don't want to get paint on. Then tape the wall edges (including at the ceiling and floor) and anything else that touches the wall that you don't want to get paint on. Cover with your drop cloth the floor and any furniture you can't move.

PAINTING

1. Start by making a pencil mark to generally show where you want each color to fade into the next.

2. Paint each section in the color that you want to fade into the next, mixing a small amount of white paint into your colors as desired to create lighter tints. We painted the top light yellow and golden yellow, the middle coral, and the bottom light pink and bright pink. Don't worry about blending at this point; just create solid color blocks. If necessary, apply a couple coats, making sure the paint is fully dry before you add another coat.

To create the light yellow and light pink colors, we mixed white paint with the golden yellow and bright pink paints.

3.

To blend the colors, start by painting a solid line of the top color and a solid line of the bottom color. Make sure each line contains plenty of paint and have the two lines just touch. With a dry brush, move back and forth where the two colors meet. Continue blending until you get the look you want.

4.

Repeat step 3 where each color meets the next. As you work, continually pause and step back to look at the whole mural. It's easy to get wrapped up in making sure a small detail is perfect, but when you take a step back, you'll see that the wall looks great!

5.

Once you're satisfied, remove the tape, let the paint dry, and clean up. You did it, and we knew you could!

Palm Leaves

JUST THE FACTS

SKILL LEVEL: Easy

TIME: 1–2 hours (not including drying time)

COLOR USED: Dark gray

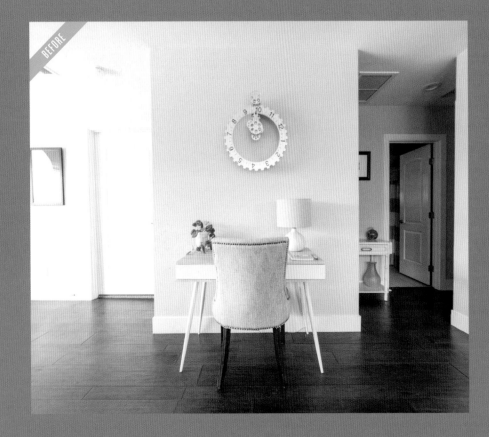

This design is a great way to bring foliage into your home if you don't have a green thumb. We used gray to keep the look more subtle, but feel free to be bold and add color. This super-simple project won't take you hours to complete, but it certainly takes your space up a few notches!

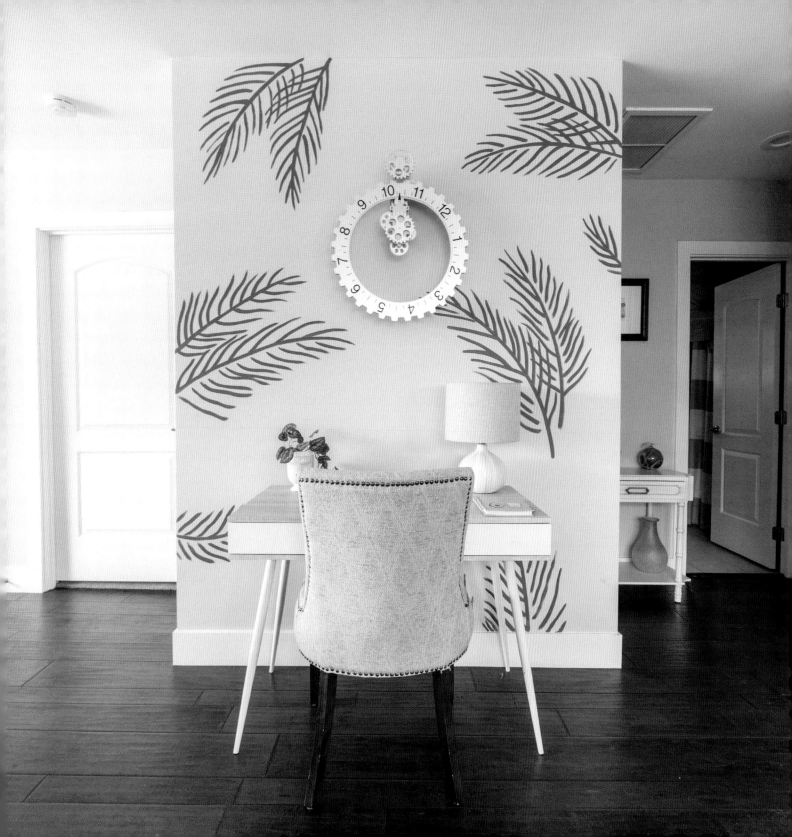

TOOLS

- ☐ 1 drop cloth
- ☐ 1–2 small brushes
- ☐ Step stool or ladder

MATERIALS

- ☐ 1 roll painter's tape
- ☐ Chalk or pencil
- ☐ 1 sample size dark gray paint

PREPPING

Move anything out of the area that you don't want to get paint on. Create a nice, open space that you can get dirty (but hopefully not too dirty)! Lay out your drop cloth to cover the ground and tape off any trim or adjoining walls. Use a credit card or gift card to smooth out the tape and make sure it's tight against the wall; otherwise paint can seep underneath.

SKETCHING

Lightly sketch your palm leaves using a piece of chalk or a pencil. You can get as detailed and obsessive as you'd like. We kept ours loose and free flowing, so it didn't take very long to sketch everything out.

We almost always prefer to use white chalk because it can be easily wiped off after painting. Pencil marks are more difficult to get rid of since you either need to erase or paint over them. In our case, our wall background was light gray, so the white chalk was visible.

PAINTING

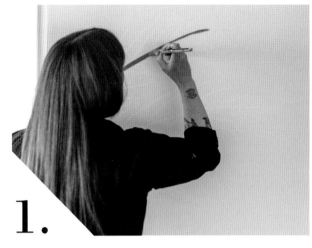

1.

Paint the main stem of a palm leaf. This will dictate where the small leaves (leaflets) branch out from. The leaflets don't have to be perfect, so embrace the brushy look! The less paint you have on your brush, the more transparent your leaves will look. Definitely don't overload your brush with paint, because you might drip onto the wall in places you didn't want paint.

Our design includes about six groups of palm leaves, but depending on the size of your wall, you can add more or use fewer.

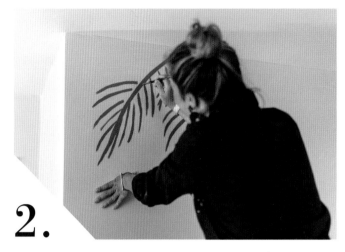

2.

If possible, work your way from the top of the wall to the bottom. It's nice to get the higher-up stuff over with so that you're standing on a ladder while you're fresh. Work on the leaves at the top, then repeat on the bottom.

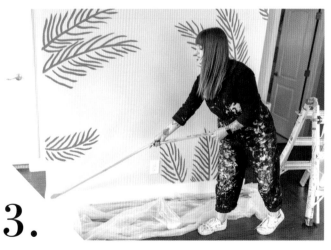

3.

Once you're satisfied with your leaves, pull off the tape. When your paint is dry, use a damp paper towel, sponge, or cloth to lightly wipe away the excess chalk (if that's what you used). Then wrap up your drop cloth, put back the furniture, and you are golden!

Vertical Stripes

JUST THE FACTS

SKILL LEVEL: Easy

TIME: 3–5 hours (not including drying time)

COLORS USED: Fuchsia, red, coral, light orange, yellow

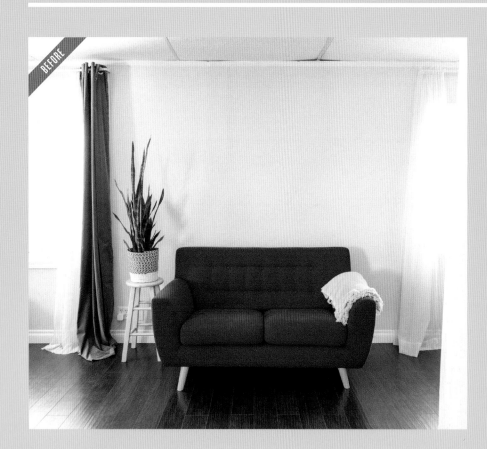

BEFORE

When it comes to painting walls, you don't have to cover the entire thing, floor to ceiling, in paint. Covering only a small portion of a wall can still make a big impact. This rainbow line design is the perfect way to bring color into any space. The lines draw the eye upward, which makes your ceilings look taller and the space seem bigger. We recommend placing this mural behind something in the room, such as a couch, bed, dresser, or crib. It will make the space feel inviting. Choose colors that complement the furniture and other items already in the room.

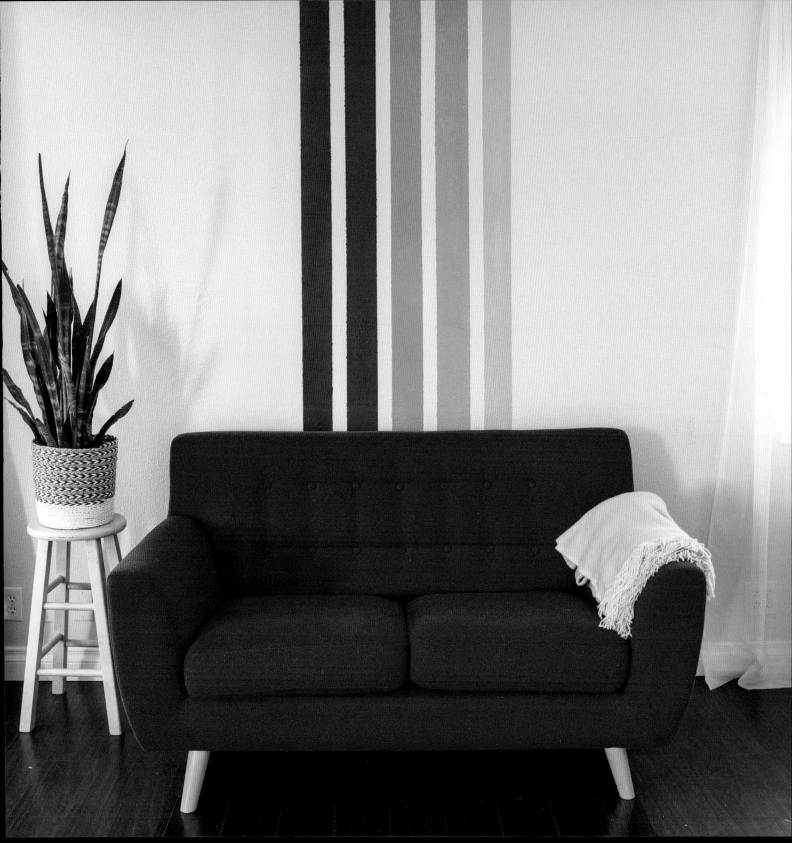

TOOLS

- ☐ 1 drop cloth
- ☐ Level
- ☐ Tape measure
- ☐ 5 brushes
- ☐ Small brush (optional)
- ☐ Step stool or ladder

MATERIALS

- ☐ 1 roll painter's tape
- ☐ Pencil
- ☐ 1 sample size of each color

PREPPING

Tape off the ceiling, floor, and anything else in the area that you don't want to get paint on accidentally. Lay your drop cloth on the ground.

MEASURING

This design consists of five stripes of color, with negative space in between. Decide how wide you want each stripe of color and how wide you want the space in between. Use those measurements to determine how wide your total mural will be. With your tape measure, find the horizontal center point of the wall. Use your pencil to make marks for each stripe on the tape along the bottom of the wall. Repeat this on the tape at the top of the wall so you know exactly where to connect the tape. If you are using the same measurements we did, you will mark out 4", 2", 4", 2", 4", 2", 4", 2", and 4" to fill the 28" space of the mural.



We decided we wanted each bar of color to be 4" wide, with 2" of space in between, so the total width of our mural was 28". We centered the design on the wall, with 14" on either side of the centerline.

1.

2.

Cover the areas with tape that you want to be the negative space in between the bars of color. Use a level to make sure the lines and tape are perfectly straight. Also tape the outside edges of the first and last sections of your color bands.

3.

Push the tape down with a credit card so your lines are nice and crisp.

When it comes to murals, we like to make things as easy for ourselves as possible. Because we wanted 2" of negative space in between the bars of color, we used 2"-wide tape. This guaranteed that the negative space would be perfect.

PAINTING

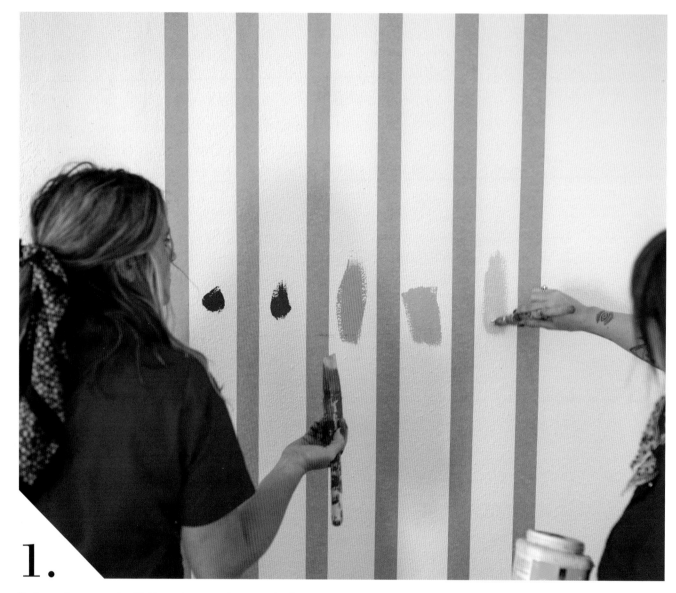

1.

Dab each segment with the color you plan to paint it. This way you won't get mixed up and paint a section the wrong color.

We use this trick whenever we're working with multiple colors in similar shapes.

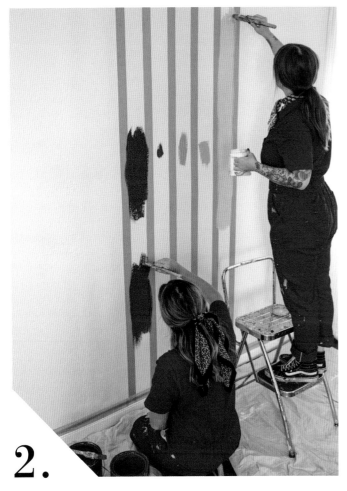

2.

Fill each section with color one at a time. If you're working with warm colors, you might have to apply a few coats to get a nice rich color.

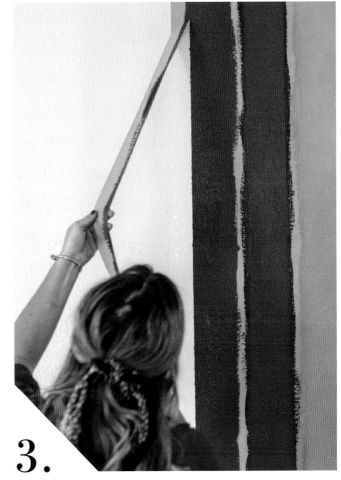

3.

When you are happy with the color, remove the tape. You might have to make minor touch-ups with a tiny brush if the tape wasn't pressed down firmly enough.

4.

Once the paint is dry, put the room back together and give yourself a pat on the back!

Ocean Scene

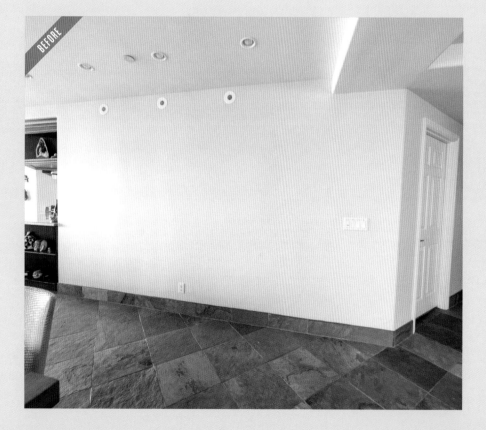

No matter where you live, you can bring a little bit of paradise to your home with this easy sunset scene. We painted this mural in a dining room, but it's sure to add life to any room! Try it in your bedroom, office, or living room.

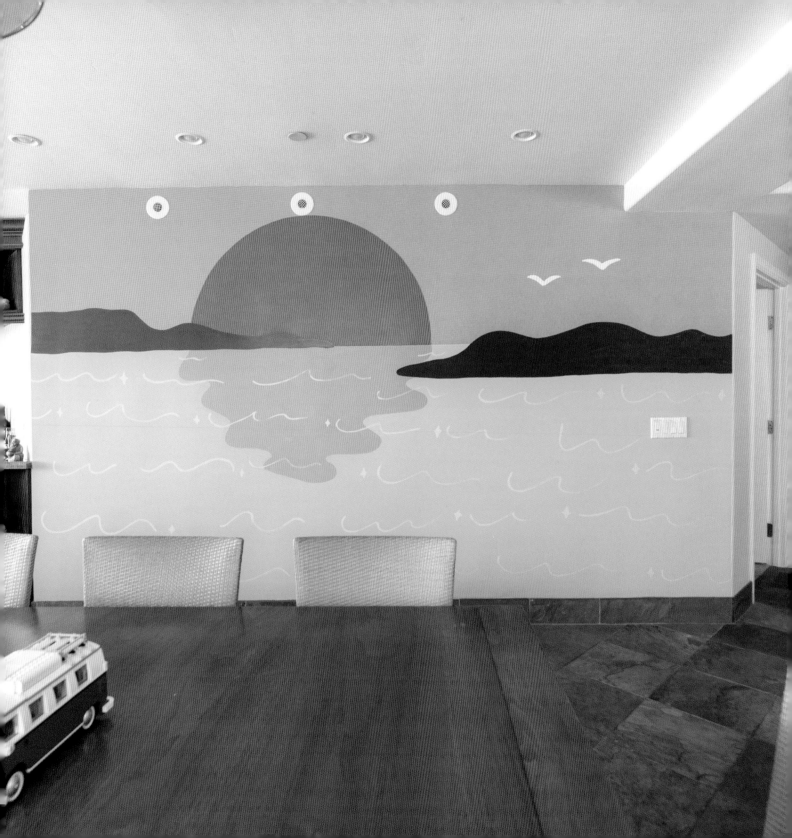

TOOLS

- ☐ 1 drop cloth
- ☐ Roller and tray
- ☐ 7–10 brushes in varying sizes
- ☐ Shoelace or piece of string
- ☐ Used coffee/soda cup for mixing colors
- ☐ Step stool or ladder

MATERIALS

- ☐ 1 roll painter's tape
- ☐ Chalk or pencil
- ☐ 1 quart light blue paint
- ☐ 1 quart light orange paint
- ☐ 1 quart brown paint
- ☐ 1 quart light brown paint
- ☐ 1 quart orange paint
- ☐ 1 sample size black paint
- ☐ 1 sample size white paint

PREPPING

Tape off everything that you don't want to get paint on, including the ceiling, floor, and trim. Lay down your drop cloth and you're ready to get started.

We put our horizon line about one-third of the way down from the top of the wall. Depending on what furniture or setup you have in your space, you might want your horizon to be higher or lower.

SKETCHING

1. Decide where on the wall you want the horizon line to be. Using chalk (if your wall is a color other than white) or a pencil, sketch the horizon line and tape it. Sketch your land shapes on either side of the wall. Remember, your shapes don't have to be perfect. This is art, okay?!

2. Figure out where you want your sun to be and sketch out its general size and shape. Your sun could be bigger or smaller than the one we created; it just depends on your preference. At this point your sun doesn't need to be perfectly round. In step 2 of the painting section, we'll show you how to use a string to make a perfect circle.

PAINTING

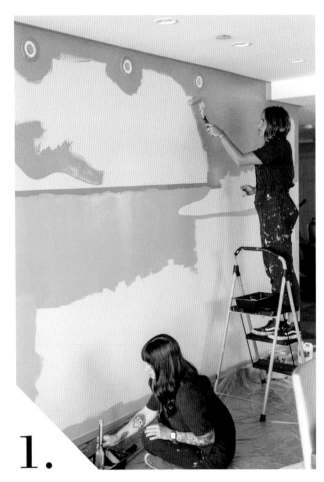

1.

Start by painting the water area light blue and the sky area light orange, leaving the area where the sun will go unpainted. Apply second and third coats if needed, allowing each coat to dry before applying the next.

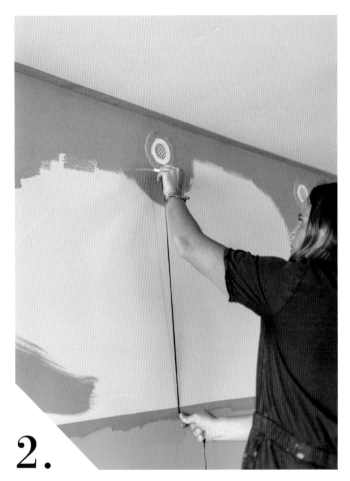

2.

Once everything is dry, mark with chalk or a pencil where the center point of the sun will be. Hold one end of a string, shoelace, or piece of yarn at the center point with one hand. With the other hand, extend the string to the top of where you want the sun and hold the pencil or chalk there. Pulling the string tight, sweep your arm with the chalk to draw a circle shape.

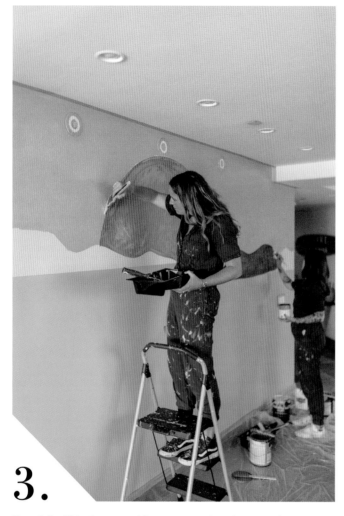

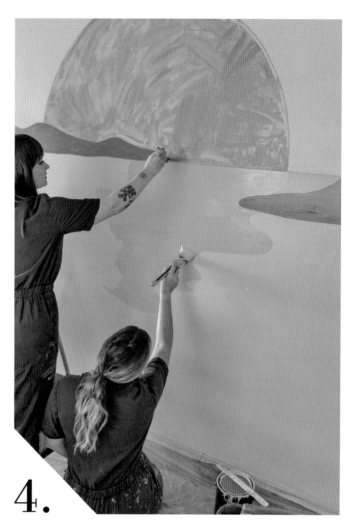

3.

Carefully fill in the sun with orange paint, then touch up the outside of the sun with light orange paint. Fill in the two land shapes with brown and light brown paint. These are essentially blobs, so it's okay if you don't paint them exactly according to your outline.

4.

While those shapes are drying, sketch the reflection of the sun over the water. This doesn't have to be perfect; basically you're looking for a wavy, longer sun shape. In a coffee cup, mix the light blue paint with a tiny bit of black to get the reflection color. Once you have the color you like, start filling in the reflection.

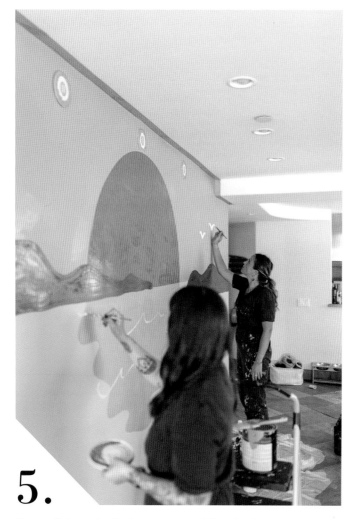

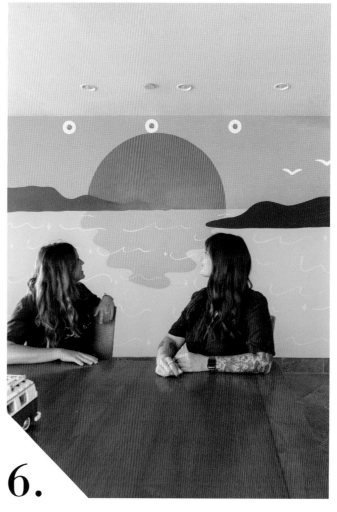

5.

Once all the paint is dry, you can add squiggles and stars over the water with white paint. If you want to add a couple birds like we did, sketch them out on the sky and fill them in using a tiny brush and white paint.

We used chalk first and then paint for our squiggles, but if you're really daring, go right in with the paint.

6.

Step back and be proud of yourself and what you've accomplished! How amazing does it look?! Clean up and reset your space.

Transparent Shapes

JUST THE FACTS

SKILL LEVEL: Medium

TIME: 5–7 hours (not including drying time)

COLORS USED: Yellow, dark green, gray, bright blue

BEFORE

This design is for our soul brothers and sisters who hate using levels or making everything perfect. If you're comfortable free handing blobby shapes, stick with us on this one! Perfectionists: Flip on over to the next project; nothing to see here!

We love this design because it can be customized to whatever space, colors, or room you like. It doesn't have to fill the entire wall. It can go in a corner. It can go up onto the ceiling or floor. Get creative with it! We thought this design would work well in this awkward area at the top of the stairs, bleeding into the corner.

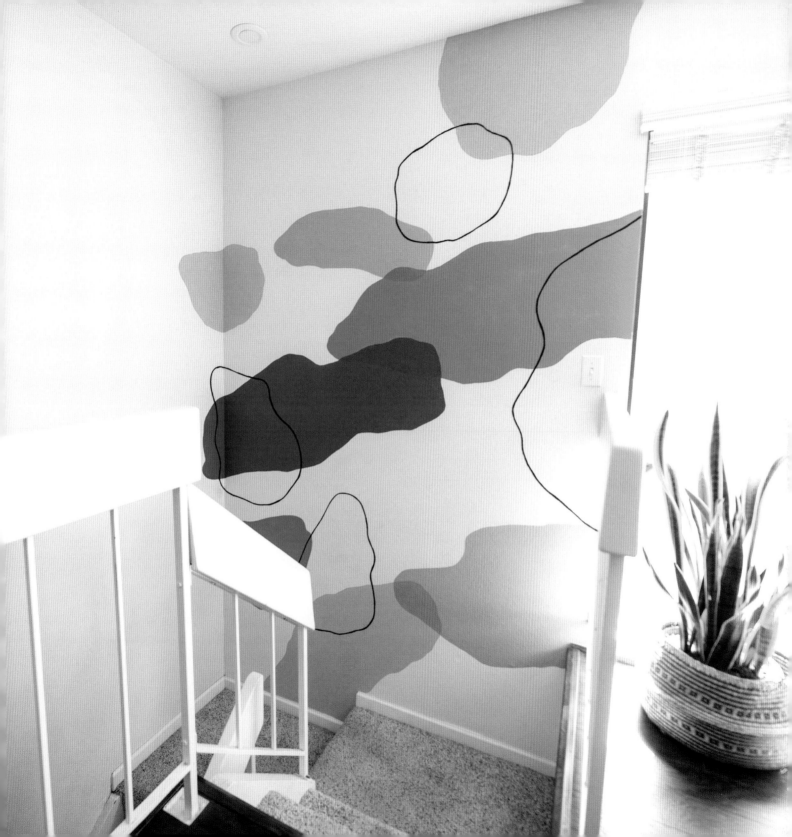

TOOLS

- ☐ 1 drop cloth
- ☐ 4–6 brushes in varying sizes
- ☐ Used coffee/soda cups for mixing colors
- ☐ 1–3 black Posca paint pens (optional)
- ☐ Step stool or ladder

MATERIALS

- ☐ 1 roll painter's tape
- ☐ Chalk or pencil
- ☐ 1 sample size or quart (depending on the size of the wall) yellow paint
- ☐ 1 sample size or quart dark green paint
- ☐ 1 sample size or quart gray paint
- ☐ 1 sample size or quart bright blue paint

PREPPING

Cover anything you don't want to get paint on. Tape off the floor, ceiling, and trim with painter's tape, and cover the ground with your drop cloth.

SKETCHING

This is where you get to be creative! Grab your pencil (if it's a white wall) or chalk (if you're working on a colored background) and start sketching out some blobs. Make sure they are varying sizes and that some of your blobs overlap for a nice layering effect. Don't worry about sketching out the black lines; you will add those on top later.

PAINTING

We like to mark a dot of paint or write the color name in pencil so we remember which color to paint each shape.

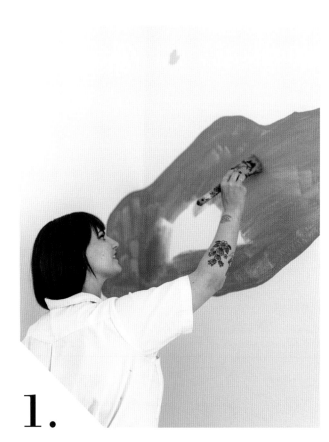

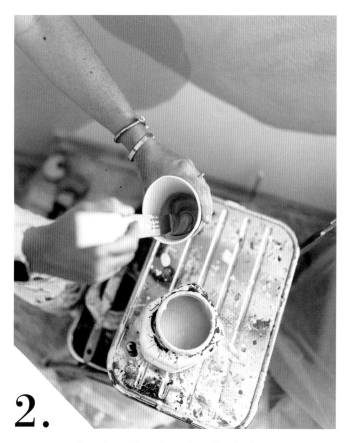

1.

Decide what color will go in each blob, leaving the overlapping sections for later. Working with one color at a time, fill in the shapes with paint until all the shapes are completed. Once the paint is dry, add a second coat if necessary.

2.

To create a layering effect that gives the illusion of transparency, mix together the two overlapping paint colors.

Anywhere that blue and gray shapes overlapped, we used a mixture of blue and gray paints.

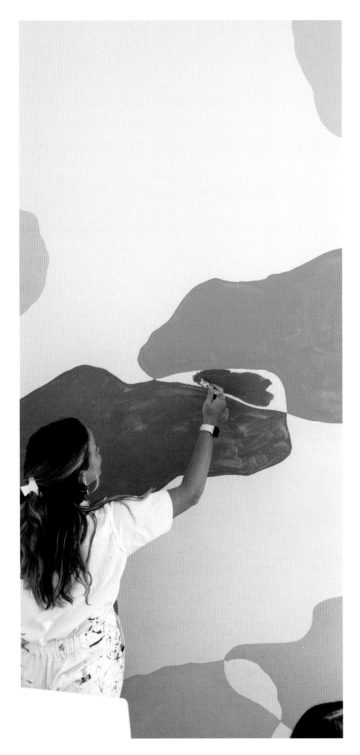

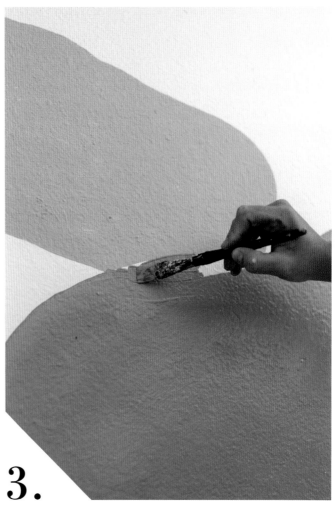

3.

Use the new paint color to fill in the sections where the shapes overlap. Wait for the paint to dry, then add a second coat if necessary.

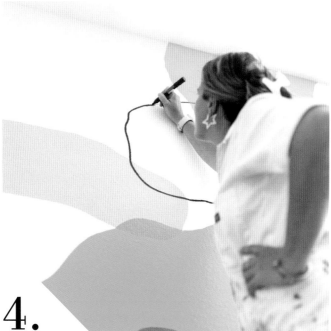

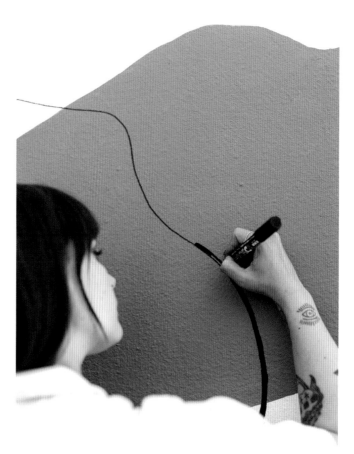

4.

If you like the mural as is, you're all done! If you want to add in some black outlines like we did, use your pencil to draw some blob shapes over the painted shapes. Trace the pencil outlines with a black paint pen, making them as thick or as thin as you'd like.

We made our outlines ½" thick. But hey, it's your wall, so if you want your lines thicker or thinner, do it!

5.

Your work is done here! Hopefully you're proud of your blobby creation. Make sure to clean everything up and reset your space.

Polka Dots

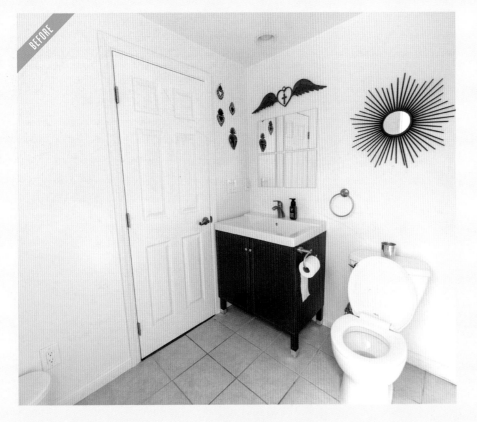

BEFORE

Bathrooms are often forgotten spaces. They don't get the color and design love they deserve. We are here to change that. This bathroom was a blank slate, so we wanted to have a lot of fun with it! Because it's a small space we didn't want to do anything too overpowering, but the owner wasn't afraid of a bold design.

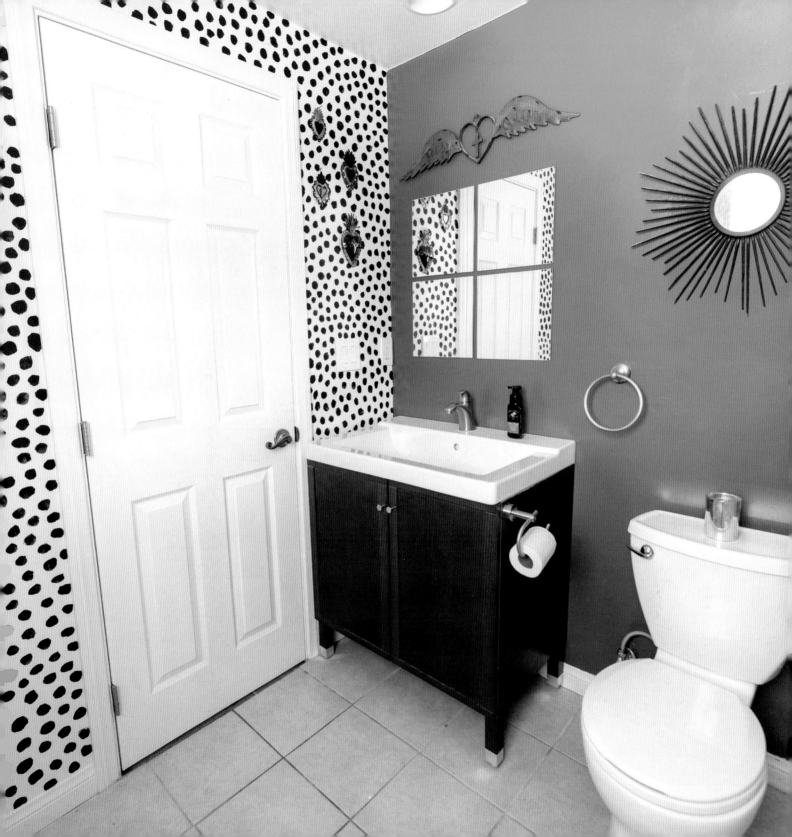

TOOLS

- ☐ 1 drop cloth
- ☐ Roller and tray
- ☐ 3–4 small brushes
- ☐ Step stool or ladder

MATERIALS

- ☐ 1 roll painter's tape
- ☐ 1 quart emerald green paint
- ☐ 1 sample size black paint

PREPPING

Tape off everything you don't want to get paint on. When in doubt, tape it out! Also remove all wall hangings, such as mirrors. Then lay down your drop cloth to cover the floor, as well as the sink and toilet. If you're using a plastic drop cloth, it can be helpful to tape it to your baseboard or trim so that it doesn't move while you're painting.

PAINTING

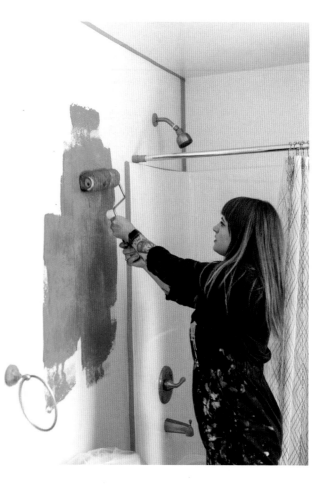

1.

Fill your tray with emerald green paint and begin to roll in the large areas. Take your time and control your movements to avoid dripping. Certain colors and paint brands may take more than two coats, so be ready to roll two to four times. Wait until the previous coat is dry before you apply more paint; otherwise the previous layer will pull up.

We started with the solid green wall first, but it's totally up to you!

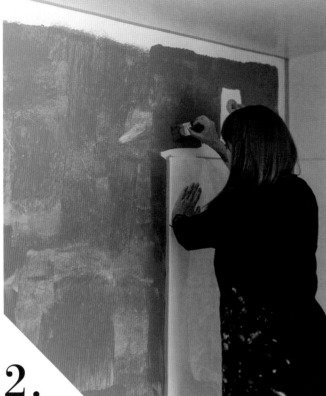

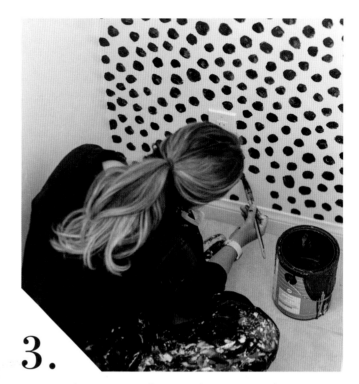

3.

For the polka-dotted wall, make black paint dabs with a small brush, then twist the brush. Twisting the brush on the wall will give you the circular shape. Your dots should be about an inch wide, with about the same distance between each one, but they don't need to be perfect. (If you want perfect circles, use a stencil.) This will become a meditative practice as you continue making dots all over your wall. Get as daringly close to the edge as you want. It's nice to have some dots bleeding off the edges so that it appears to be wallpaper that was trimmed perfectly to fit your space. Black paint should go on well without multiple coats, but feel free to touch up any polka dots that appear see-through.

2.

Use a small-to-medium-size brush to paint around the edges of the wall and the tough-to-reach places (like behind the toilet). This will give you more control than if you use a roller. Luckily, not many people look behind the toilet, so don't worry if you don't paint it perfectly! But take your time to carefully paint around the sink and shower and other highly visible edges. Use an even smaller brush if you need more control. It'll take you longer but will probably put your mind at ease.

4.

When you're satisfied with your paint job, start cleaning up. Remove all tape and use tiny brushes to do touch-ups if needed. Lastly, stand back and admire your work!

Color Blocking

JUST THE FACTS

SKILL LEVEL: Easy

TIME: 1–2 hours (not including drying time)

COLORS USED: Dark pink and peach

BEFORE

This is a super-easy way to add some color to your bathroom without going overboard. Because there are no windows in this bathroom, we used bright colors to avoid making the room feel too dark.

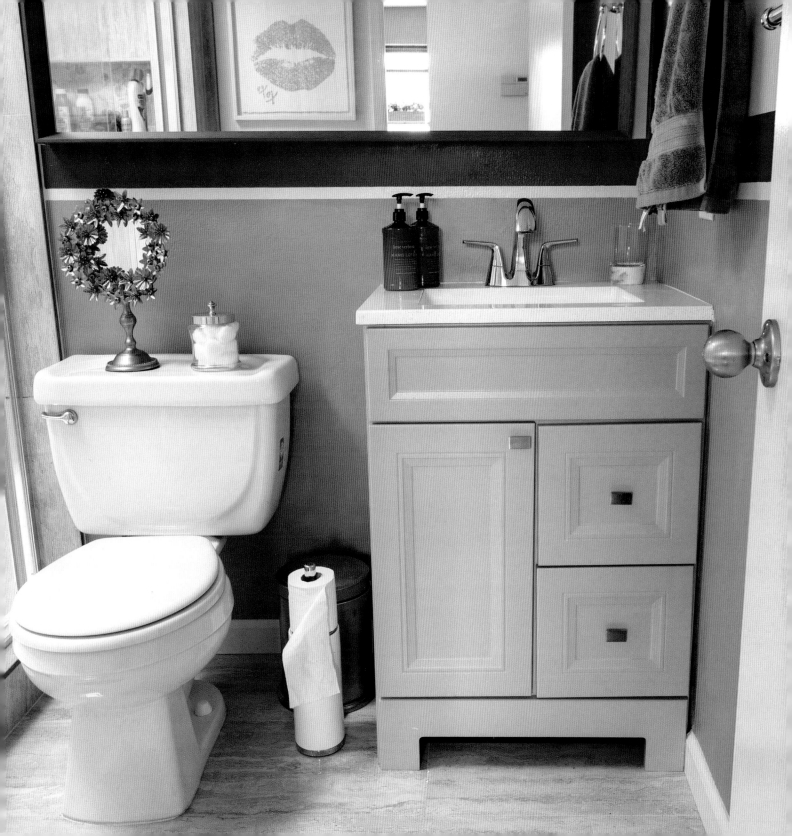

TOOLS

☐ 1 drop cloth

☐ Tape measure

☐ Level

☐ 3–4 brushes in varying sizes

☐ Roller and tray

MATERIALS

☐ 1 roll painter's tape

☐ Pencil

☐ 1 sample size dark pink paint

☐ 1 quart peach paint

PREPPING

Tape off everything that you don't want to get paint on and lay out your drop cloth to protect the flooring and toilet.

MEASURING AND TAPING

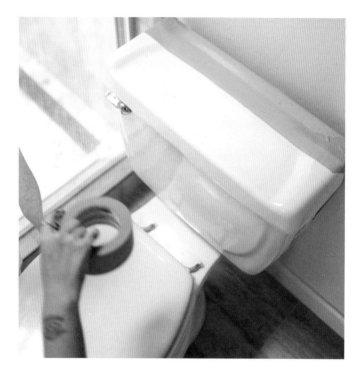

1.

Measure from the floor to the edge of the sink. Using a pencil, make a small mark on the wall where you want the top of your peach section and the bottom of the negative space to be. Repeat this mark every few inches or feet, depending on how long your wall is, to indicate the top of your peach section. Faucets and sink handles can be tricky to navigate behind, so make your life easier and paint only with your bottom color in those areas.

We designed the color blocks in this mural to align with the sink, positioning the negative space about a third of the way down from the mirror above the sink. Depending on how your bathroom is structured, you might want your negative space to be higher or lower. As long as you measure and your lines are consistent, you can have your color blocks divide the wall wherever you want.

2. Apply tape to create a straight edge, connecting each of the marks you made in step 1 and moving slowly to allow less room for error. Use a level to check that your tape line is parallel to the floor, and adjust as necessary. Smooth out the tape by rubbing a credit card or gift card over it. You want the tape secured to the wall as tightly as possible so that paint doesn't seep underneath. The tape will create negative space between the two color blocks.

3. Decide how tall you want your upper stripe to be. Measure from the top of the tape and make multiple pencil marks to show where the dark pink section will end. Apply tape to connect these marks, then use a level to ensure the line is parallel to the floor. Seal the tape as tightly as possible.

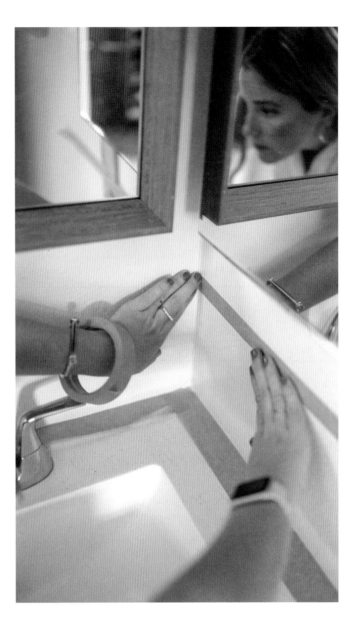

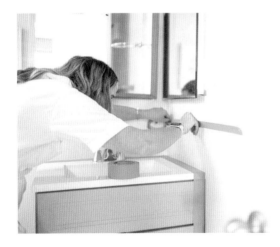

PAINTING

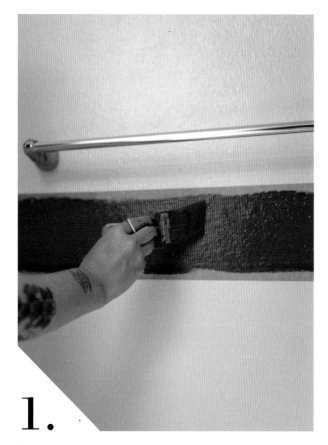

1.

Paint the dark pink stripe with a medium-size brush. The tape will protect the edges of the strip, so don't worry if your brush is slightly wider than the finished stripe will be.

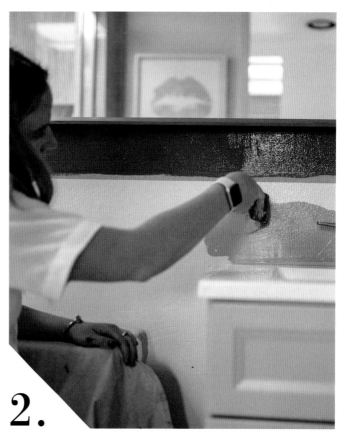

2.

Use a smaller brush and the peach paint to paint around the edges of the sink, toilet, and other obstructions in your space. The smaller the brush, the easier it is to reach tight areas. Once you're comfortable with the edges, fill in the larger surface area of the wall with a bigger brush or roller.

Different colors require different amounts of paint. If you need multiple coats, give your paint time to dry in between coats. Feel free to turn on an overhead fan or bring a fan into the room to speed up the drying time.

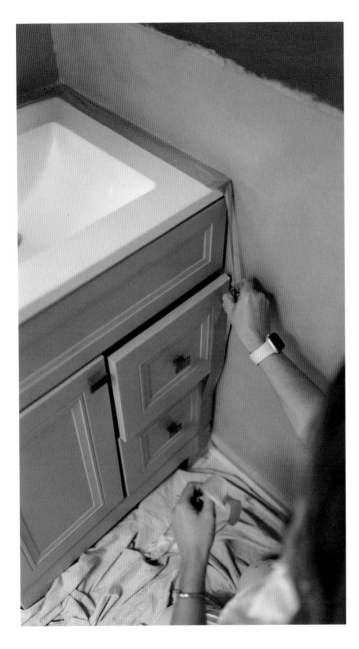

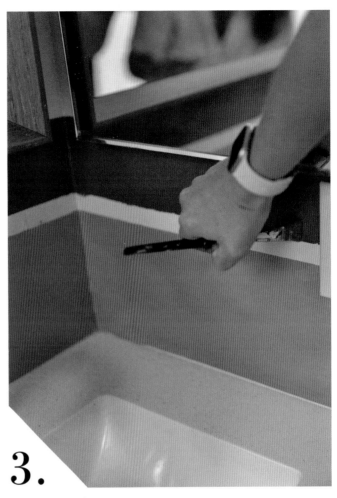

3.

Once the colors look solid and there are no see-through patches, peel off the tape. Use a baby brush for any touch-ups.

Simple Typography

JUST THE FACTS

SKILL LEVEL: Medium

TIME: 5–7 hours (not including drying time)

COLORS USED: Scallion green, light pink, white

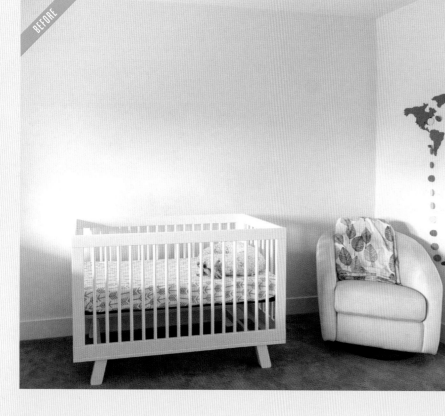

BEFORE

We had a vision for painting a girl's nursery, but we didn't want the room to feel overly pink and girlie. We wanted to show that you can paint a room green and still make it feel feminine. We also wanted to show that a simple design can have a really big impact on a room.

For this design we chose a short phrase paired with a simple flower illustration. Since we wanted the letters to be absolutely perfect, we used a projector to get the artwork on the wall. If you like this design, you can download it. See page 202 for details.

NOTE: A projector can be expensive, but we wanted to show you this great technique for getting complicated art on the wall. The projector we use is made for watching movies, so you might have one already or know someone who does.

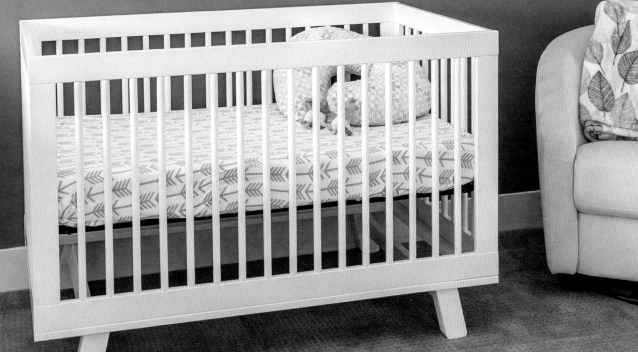

TOOLS

- ☐ 1 drop cloth
- ☐ 3–4 brushes in varying sizes
- ☐ Roller and tray
- ☐ Downloaded design, optional (see page 202)
- ☐ Projector
- ☐ Level
- ☐ Tape measure
- ☐ Step stool or ladder

MATERIALS

- ☐ 1 roll painter's tape
- ☐ 1 gallon scallion green paint
- ☐ Pencil
- ☐ Chalk
- ☐ 1 sample size pink paint
- ☐ 1 quart white paint

PREPPING

Tape off everything you don't want to get paint on, including the wall edges and trim. Set up your drop cloth to protect the floor.

PAINTING

1.

Start by painting the background. Use a 2" brush to paint the edges, then fill in the main area of the wall with a roller. You will probably need two coats of paint. Be sure the first coat is fully dry before you start a second coat. Wrap your brushes in plastic wrap while the first coat dries. While you wait, you could . . . go for a walk, call your best friend, learn a new dance from an online video, make yourself lunch, you get the idea.

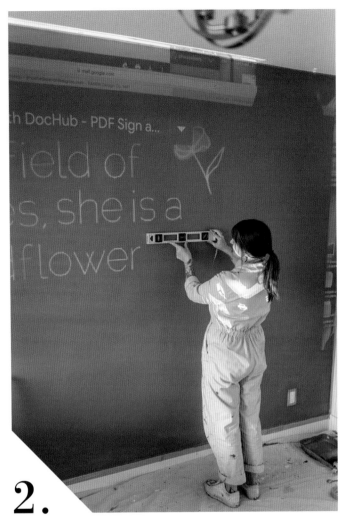

in a field of roses, she is a wildflower

We like to use a projector when we're working on an intricate design or something that we need to be perfect. Most projectors plug directly into a laptop with an HDMI cord, allowing whatever is on your screen to show up on the wall.

2.

Decide where you want the lettering to be, then project the design on the wall. Use a level to make sure the lettering is straight, then mark the lines on the wall with a pencil.

While you're tracing, you have to stand to the side so you're not blocking the projector. This might feel a little awkward at first, but you'll get the hang of it.

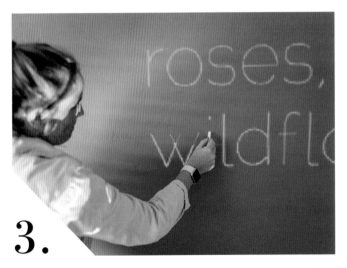

3.

Outline your art on the wall with chalk. Keep a wet washcloth handy in case you need to erase anything. You can use a pencil instead of chalk, but if you do, make your marks very light since pencil is hard to cover with light-colored paint.

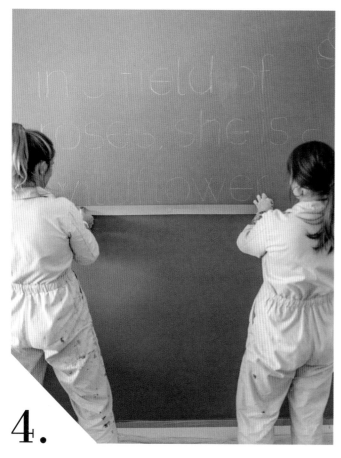

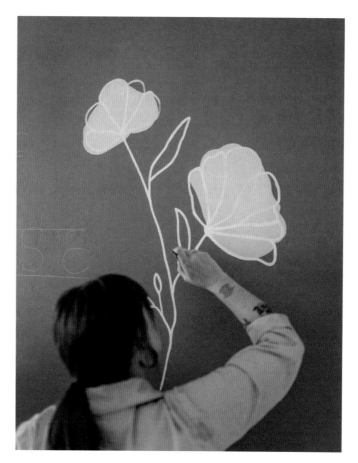

4.

After you have outlined the artwork, measure everything again, check that it is level, and tweak anything you need to. Mark the tops and bottoms of the letters with tape so that everything is nice and clean.

We designed the flowers to look abstract, with pink below and white lines on top.

5. Paint the pink background color of the flowers. When that is dry, paint the white lines over the pink.

6. With a small brush, carefully paint the letters. The total width of the bristles will determine the thickness of your lines. Don't worry if your lines aren't totally perfect; just keep your background color handy so you can fix anything you need to at the end.

7. After you touch up any final lines, clean up and reset the space.

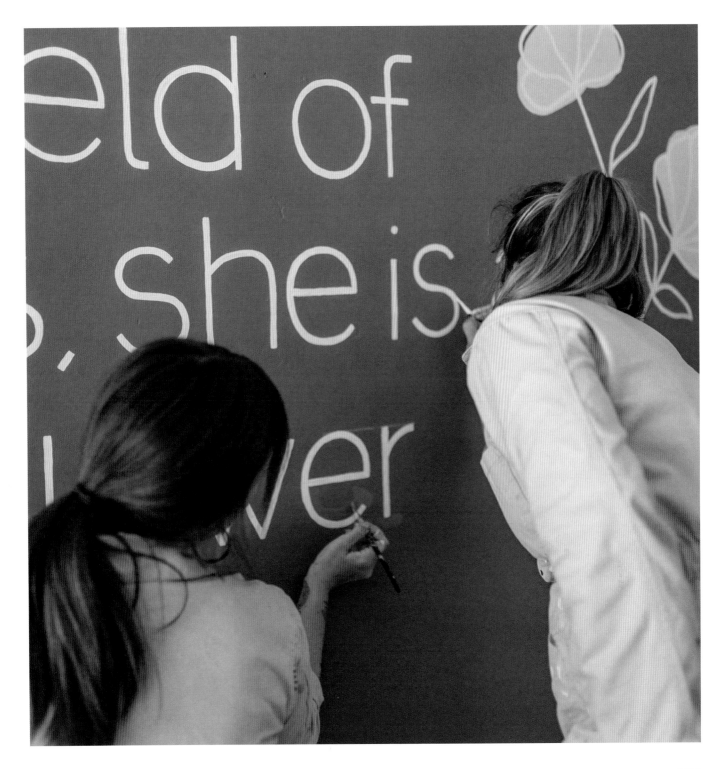

Clean Diamonds

This project is for those of you who aren't ready to commit to painting a full wall but still want something unique in your space. The general design can be as large or as small as you'd like, so get creative! Also, you don't need to draw or paint anything freehand with this one because everything is done with tape. This design might not be the best option if your wall has some texture to it—unless you're okay with a little bit of imperfection.

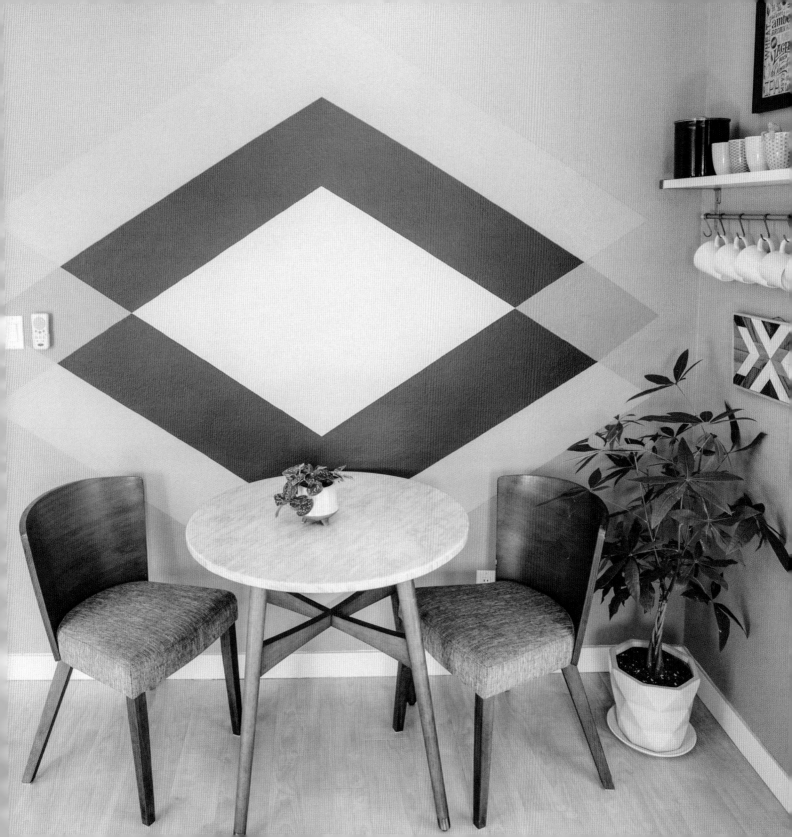

TOOLS

- [] 1 drop cloth
- [] Tape measure
- [] 8 small-to-medium brushes
- [] Used coffee/soda cup for mixing colors
- [] Step stool or ladder

MATERIALS

- [] Chalk
- [] 1 roll painter's tape
- [] 1 quart white paint
- [] 1 quart light blue paint
- [] 1 quart purple paint

PREPPING

Clear your space of any furniture, then put down your drop cloth to protect the floor.

MEASURING AND TAPING

1.

This design is symmetrical. Start by finding the middle of your wall both vertically and horizontally, and mark that with chalk. This will be the center point of your mural.

2.

Measure and mark 3' above and below, and to the right and to the left of the center point. In the diagram on the facing page, these points are labeled *A*, *B*, *C*, and *D*.

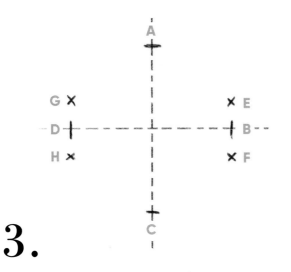

3.

Measure and mark 1' above and below points B and D. The new points are labeled *E*, *F*, *G*, and *H*. With tape, connect points G and A; points E and A; points H and C; and points F and C.

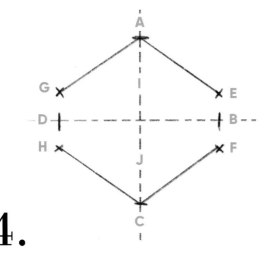

4.

Along the imaginary vertical centerline, mark two new points (I and J), parallel with points G and E and points H and F, respectively. Use tape to connect point I with points H and F below the horizontal centerline, and connect point J with points G and E above the horizontal centerline. This will create a main diamond in the center.

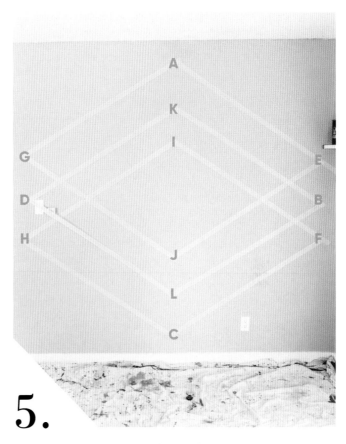

5.

Along the imaginary vertical centerline, measure and mark point K halfway between points A and I, and mark point L halfway between points J and C. Use tape to connect point K with points D and B, and point L with points D and B, forming the third diamond.

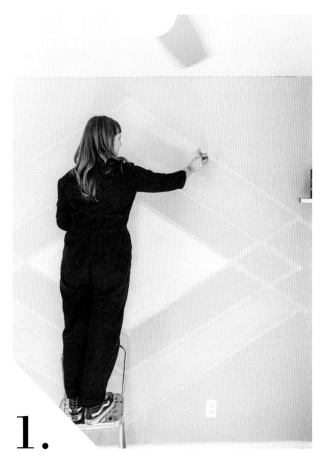

1.

Use a medium brush to paint the center diamond white. Then fill in the top and bottom shapes with light blue paint. Repeat as necessary until the shapes are fully covered, letting the paint dry in between layers.

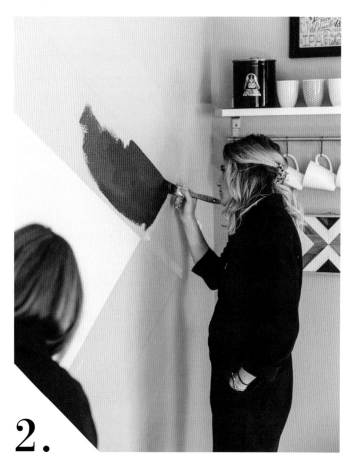

2.

When those shapes look opaque, take off the surrounding tape. Using new tape, connect the edges of the light blue shapes and white diamond as shown. Paint in between the light blue and white shapes with purple, working slowly and carefully along the white and blue edges to ensure clean, straight lines. If you are worried about getting purple paint in the white or blue areas, wait until those shapes are fully dry, tape their edges, and then paint the spaces in between with purple.

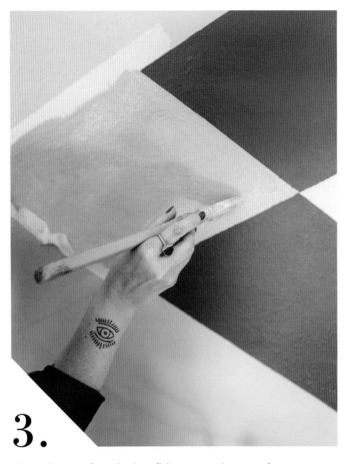

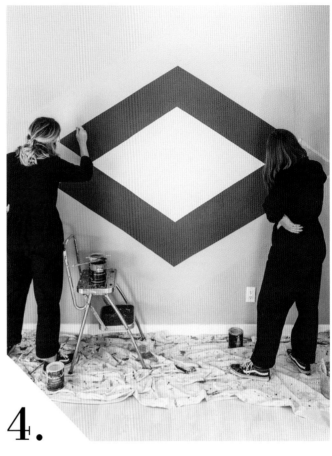

3.

When the purple paint is solid, remove the tape from step 2 and create your last tape diamonds. Connect the edges of the purple sections to points D and B. Step back to make sure everything looks symmetrical. Then mix your purple and blue paints in a cup to create a blend of the two. When you're content with the mixture, paint in the two remaining diamonds until they are solid. If you are worried about getting paint in the purple areas, wait until those shapes are fully dry, tape their edges, and then paint the spaces in between.

4.

Remove the last bits of tape and use a small brush to touch up any spots that may need to be fixed. When all the paint is dry, wipe off any excess chalk with a damp sponge or paper towel. Then clean up your paint supplies and drop cloth, put back the furniture, and you're ready to enjoy your new mural!

Sponge Brush Pattern

JUST THE FACTS

SKILL LEVEL: Easy

TIME: 2–3 hours (not including drying time)

COLORS USED: Light blue and white

Who says spending lots of money on a tile backsplash is the only way to update your kitchen? An easy and inexpensive alternative is paint! You can use this technique in a kitchen, like we did, or to add a subtle pattern to any wall in your home. To customize this project, simply pick colors that work with your space.

TOOLS

- ☐ 1 drop cloth
- ☐ Roller and tray
- ☐ 2 brushes in varying sizes
- ☐ 1 sponge brush
- ☐ Step stool or ladder

MATERIALS

- ☐ 1 roll painter's tape
- ☐ 1 quart light blue paint
- ☐ 1 sample size white paint

PREPPING

Tape off all the edges of the wall, including the floor, ceiling, trim, and anywhere else you don't want to get paint. Cover the floor with a drop cloth.

PAINTING

1. Use a roller or brushes to paint the background light blue. If the paint isn't giving you the coverage you'd like, let it dry and apply a second (or even third) coat.

2. Once the background is completely dry, it's time to paint the pattern, which we created to look hand-done. In other words, it's not meant to be perfect, so have fun with it! With a little bit of white paint on your sponge brush, dab several vertical lines on the wall with a few inches in between each one. Offset each row slightly to create a bit of a zigzag pattern across the wall. Continue in this manner until you fill the entire wall. Again, don't worry if it's not perfect. That adds to the artistry!

We tried to line up each sponge dab with the center of the sponge dab on either side.

3. Clean up as you let the paint dry. See? That wasn't so hard!

Geometric Shapes

JUST THE FACTS

SKILL LEVEL: Medium

TIME: 3–5 hours (not including drying time)

COLORS USED: Dark pink, coral, gray

BEFORE

Chances are you have a space in your house or apartment that you just don't know what to do with. We came up with this geometric design for exactly that kind of awkward space. It immediately gave the room an artistic and creative vibe. Painting squares and circles is an easy way to bring art into a space without dropping a pretty penny at a gallery!

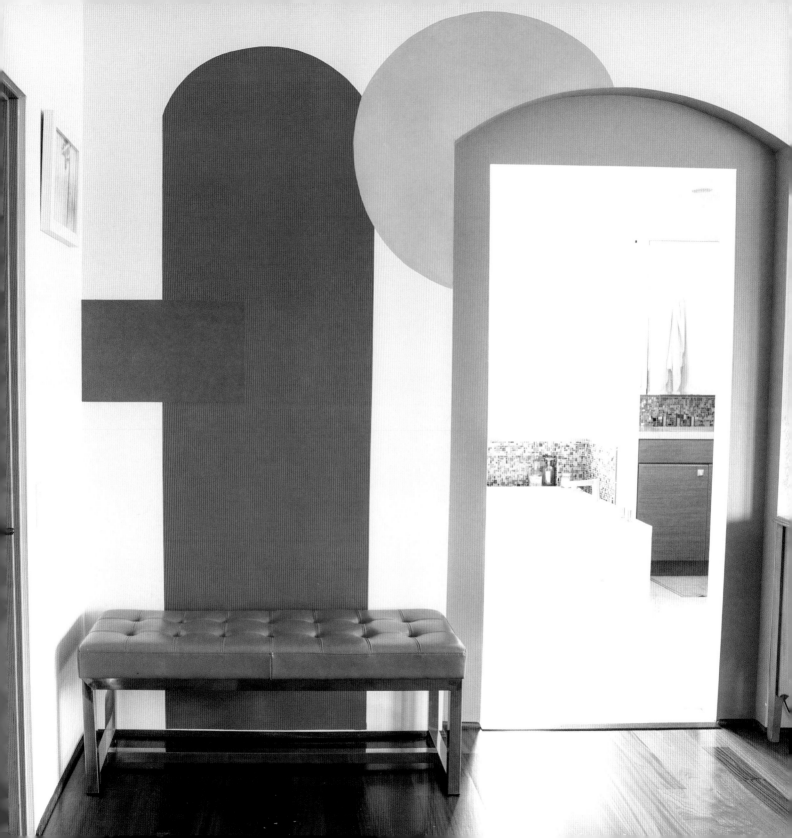

TOOLS

- ☐ 1 drop cloth
- ☐ Tape measure
- ☐ Shoelace or piece of string
- ☐ 5–6 brushes in varying sizes
- ☐ Step stool or ladder

MATERIALS

- ☐ 1 roll painter's tape
- ☐ Pencil
- ☐ 1 quart dark pink paint
- ☐ 1 quart coral paint
- ☐ 1 quart gray paint

PREPPING

Tape off the edges of the wall, including the ceiling, trim, and anything else you don't want to get paint on. Lay a drop cloth on the floor to protect it.

MEASURING

Since your wall is probably not the same size as the one shown here, we will teach you how to create this design proportional to the size of the wall.

1.

Use a tape measure to find the center of your wall both horizontally and vertically. Mark the center point with a piece of tape.

2.

That center point will be the top right corner of the rectangle (shape A). Measure 14" down from the center point and tape the outside edges of shape A, which should extend left to the corner of the wall.

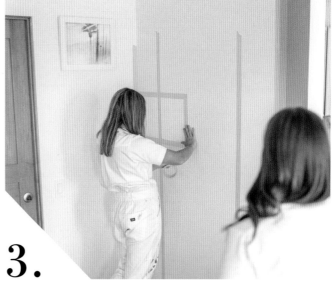

3.

Measure 8" in from either side of the wall and tape along these lines parallel to the edges of the wall. These will be the edges of your long middle shape (shape B).

TRACING CIRCLES

Remember in geometry class when you learned about the diameter, radius, and circumference of a circle, and you thought, "I'm never going to use this in the real world"? Well, you are today! We're going to show you how to trace circles and half circles using a pencil and a string. For demonstration purposes, we're using Roxy's shoelace.

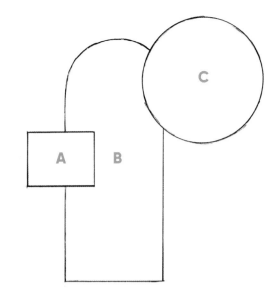

It might take a couple tries to get the circle perfect, so make your pencil marks very light.

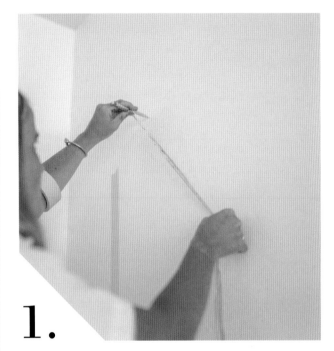

1.

Toward the top of shape B, place a piece of tape to mark what will be the center of the top of its curve. Measure the full width of shape B and fold your string to be half of this measurement. Wrap or tie one end of the string around the pencil and place the pencil on the corner of shape A. Pull the string taut and hold the opposite end firmly against the wall. You've essentially created a homemade compass. Keep the string tight and move the pencil up and around to the opposite corner of shape B. You should now have a perfect half circle.

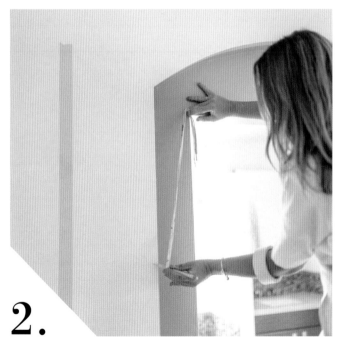

2.

Decide how big you want the full circle (shape C) to be. Find the middle point of shape C and repeat the process explained in step 1 to draw the full circle.

PAINTING

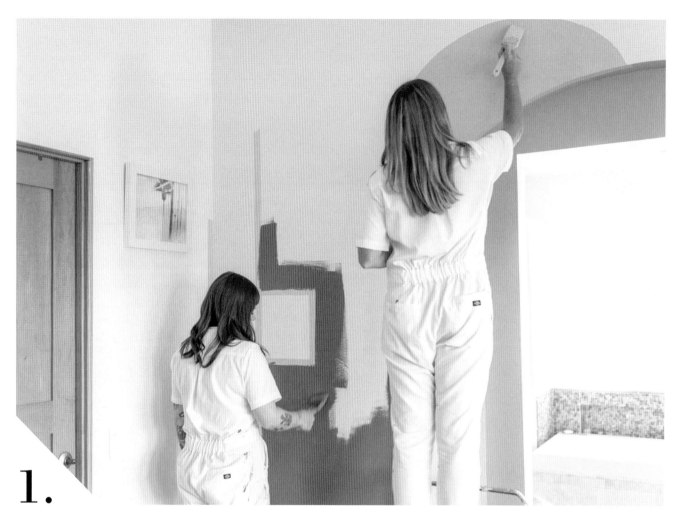

1.

Paint shape B dark pink, then paint shape C coral. Wait until each color dries, then paint the areas that connect and overlap.

—

Make sure you have some paint in the background color handy in case you need to touch up the wall!

2.

Carefully remove the tape from the rounded part of shape B and from shape C. When the paint is fully dry, tape around the outside edges of shape A, then fill it in with gray paint, working carefully and slowly where it meets shape B.

3.

Take off the tape and clean up the rest of the space while you wait for the paint to dry.

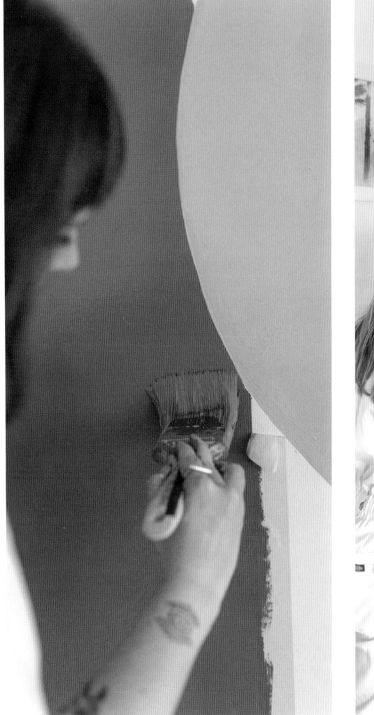

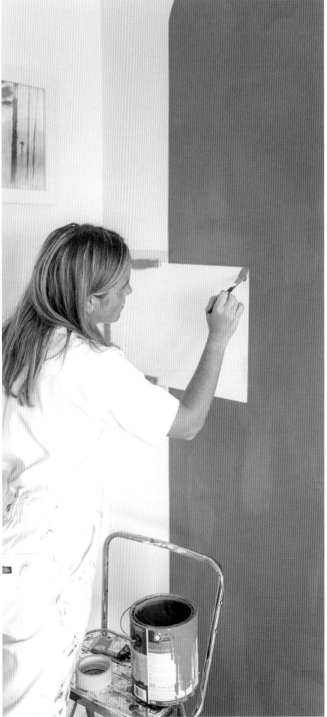

Floral Stencil

JUST THE FACTS

SKILL LEVEL: Medium

TIME: 4–5 hours (not including drying time)

COLORS USED: Orange and white

BEFORE

Whether you use the color orange or something else, this project will brighten your room instantly. We chose orange because of the bedding, but feel free to go in a different direction. The floral stencil is an easy way to add a playful element on top of your bold color statement. Again, we chose floral to match the bedding, but you could make a stencil of whatever floats your boat!

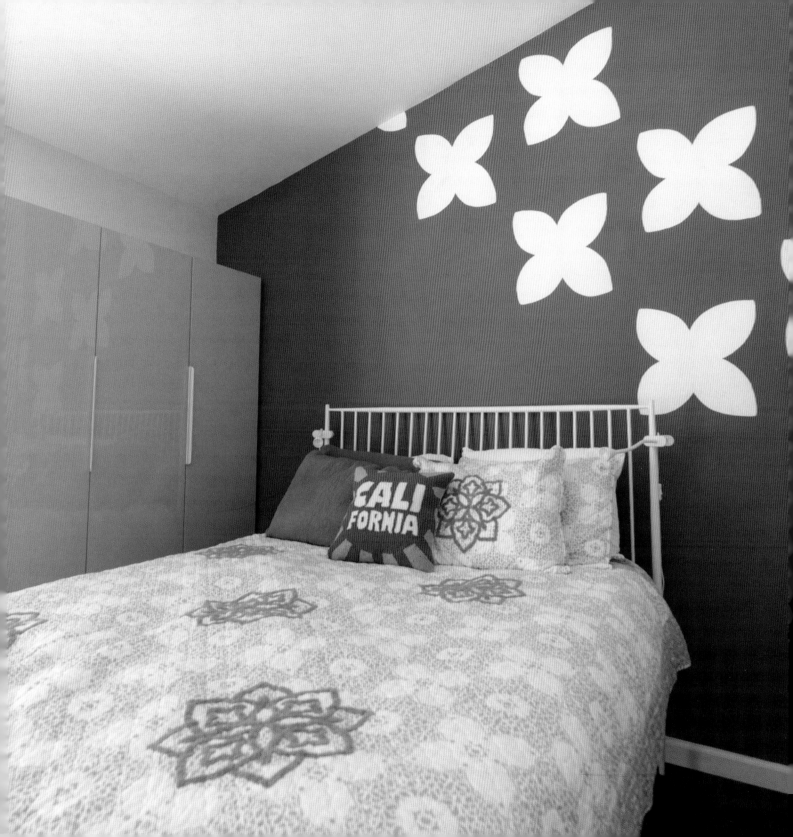

- ☐ 1 drop cloth
- ☐ 2 medium-to-large brushes
- ☐ 2 small-to-medium brushes
- ☐ Roller and tray
- ☐ Scissors
- ☐ Tape measure
- ☐ Step stool or ladder

MATERIALS

- ☐ 1 roll painter's tape
- ☐ 1 gallon orange paint
- ☐ Pencil
- ☐ Chalk
- ☐ 1 printout of the floral stencil design (see page 202)
- ☐ Craft paper or paper grocery bag
- ☐ 1 quart white paint

PREPPING

Move any furniture out of the way, then tape all of the edges, including the ceiling. Try to get the tape as tight to the wall as possible so that no paint seeps underneath. Lay out your drop cloth.

PAINTING

1. Use a larger brush to paint along the edges and tape. Then fill in the rest of the surface area using a roller. Orange typically needs multiple coats, so don't get discouraged if it's still see-through after one or two coats. Let the wall dry in between each coat and take a break. Painting can be taxing on the body!

 You want a good amount of paint on your roller, but not so much that it drips everywhere.

2. When the wall is opaque, you're ready for the floral stencil on top. Here comes the fun part. If you haven't downloaded and printed the stencil design, do so now. Trace it onto craft paper or a paper grocery bag, then cut it out.

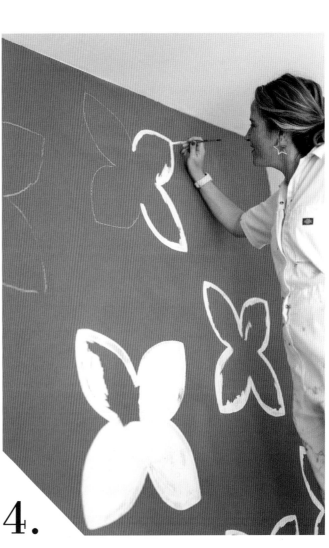

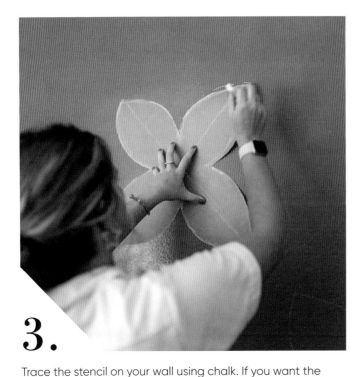

3. Trace the stencil on your wall using chalk. If you want the distance between each shape to be the same, use a tape measure as you work. And if you don't like where you've placed any of the shapes, wipe off the chalk with a damp rag, then retrace the stencil where you want it.

Our shapes are staggered on a diagonal, but you can lay out yours however you'd like.

4. Outline each shape with white paint, then fill in the shapes. Like orange, white paint usually takes a few coats, so keep repeating until your shapes are opaque.

5. Remove all tape along the walls and clean up your other supplies. When the paint is dry, wipe off any excess chalk with a damp rag. Put back the furniture.

Triangle Headboard

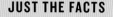

JUST THE FACTS

SKILL LEVEL: Easy

TIME: 3–5 hours (not including drying time)

COLORS USED: White and maroon

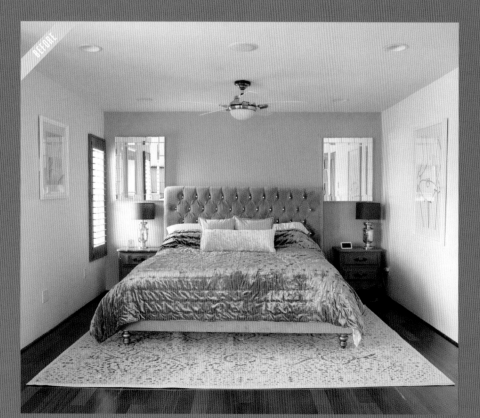

This geometric headboard is a piece of cake. Choose whatever colors you want to match your sheets, carpet, or whatever you have going on in your room. We show a triangle example, but you could make whatever shape you'd like. (Pro tip: We find a triangle shape to be the easiest.)

This wall was already painted pink before we started. If you want to re-create our design exactly, you'll need a gallon of pink paint. After taping the edges and laying down your drop cloth, paint the whole wall pink and let it dry completely before you start measuring and taping the triangle shape.

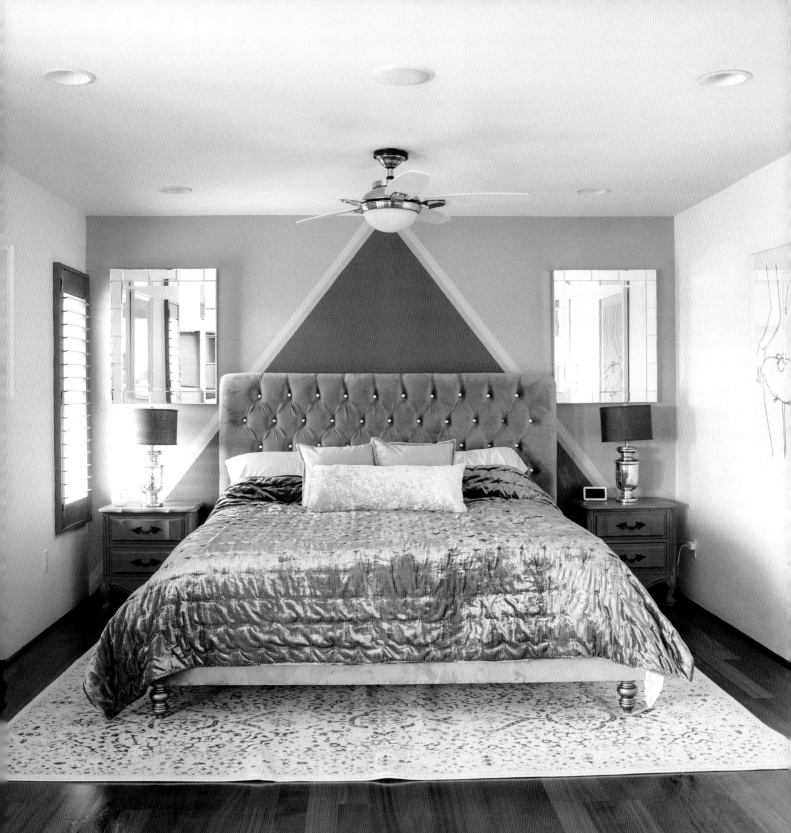

PREPPING

Lay out the drop cloth, then tape anything that you want protected from paint, including the ceiling, baseboards, or other trim. Take your time taping and press firmly so that you are sure to keep paint off of these areas.

MEASURING AND TAPING

1. Measure the width of the wall and divide it by 2. Mark the center point at the ceiling with either chalk or pencil. (If you're using pencil, mark very lightly.)

2. To create one large triangle, place a piece of tape going from the center ceiling mark to the bottom right corner of the wall. Repeat on the left side to complete your main triangle shape.

Remember to smooth out the tape with a credit card to ensure that it is secured tightly against the surface.

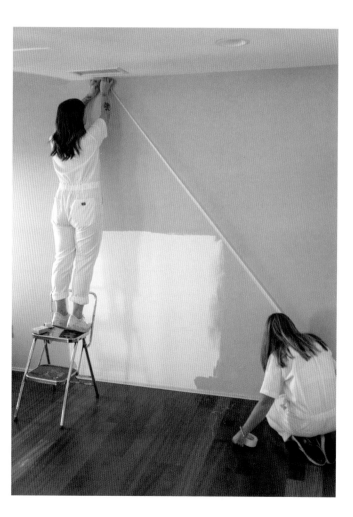

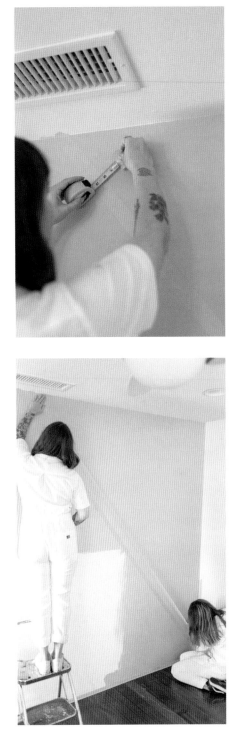

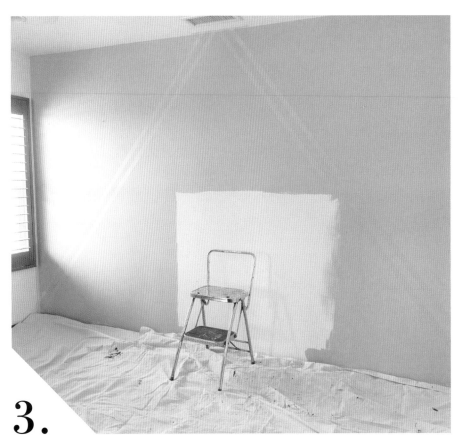

3.

You can keep your headboard simple and use only one triangle. Or, if you're feeling fancy, you can add an outline like we did. To add the outline, place about 2' of tape along the center point at the ceiling to protect the ceiling from paint. Measure and mark 2" from the right edge of your right strip of tape at the ceiling, in the middle, and at the bottom corner. Connect these marks with a long strip of tape. This piece should be parallel to your original triangle tape line, so take your time. Repeat on the left side of the triangle, again making sure to keep the tape parallel to the original tape line.

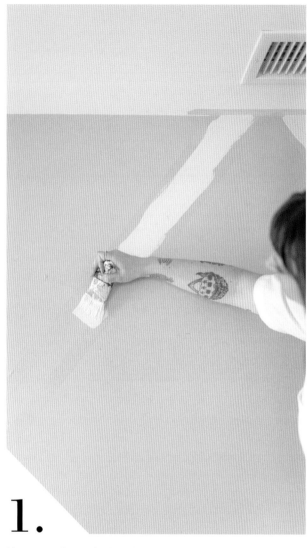

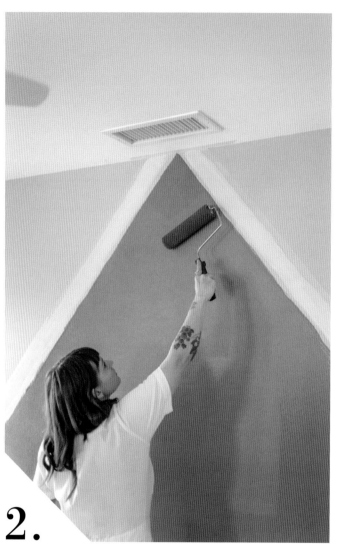

1.

Use a medium-size brush to paint the 2" white stripes on the left and right sides of the main triangle.

We used white, but you can use whatever color you want.

2.

For the main triangle, use a small or medium brush to paint along the inside of the tape. Then cover the rest of the surface area with a roller. Most paint will require a minimum of two coats. Wait for your first coat to dry entirely before painting over it again.

3. Remove the tape, clean up the area, and
set up your bedroom again!

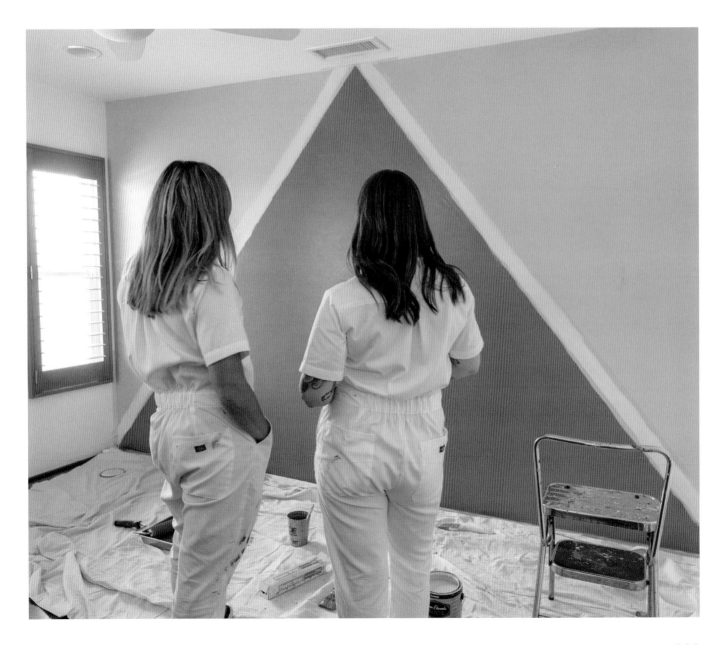

Complex Flowers

JUST THE FACTS

SKILL LEVEL: Difficult

TIME: 4–5 hours (not including drying time)

COLORS USED: Yellow, white, gray, purple, black

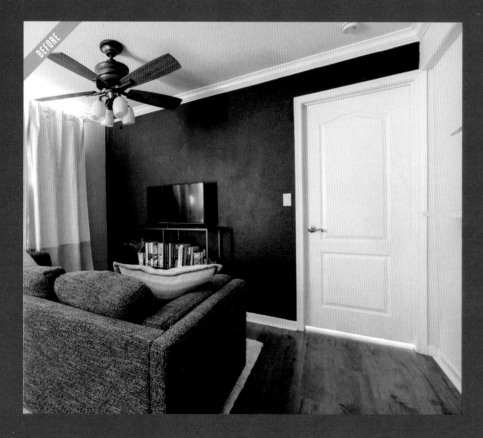

BEFORE

This project is probably one of the most complicated in the book, but the payoff is big. These sophisticated flowers bring a level of elegance to the room. We also incorporated dimension into the design by having the mural melt onto the doorframe. This creates visual interest and a fun surprise when you view it from different angles!

NOTE: A projector can be expensive, but this is a great technique for getting complicated art on the wall. Our projector is made for watching movies; you might have a similar one already or know someone who does.

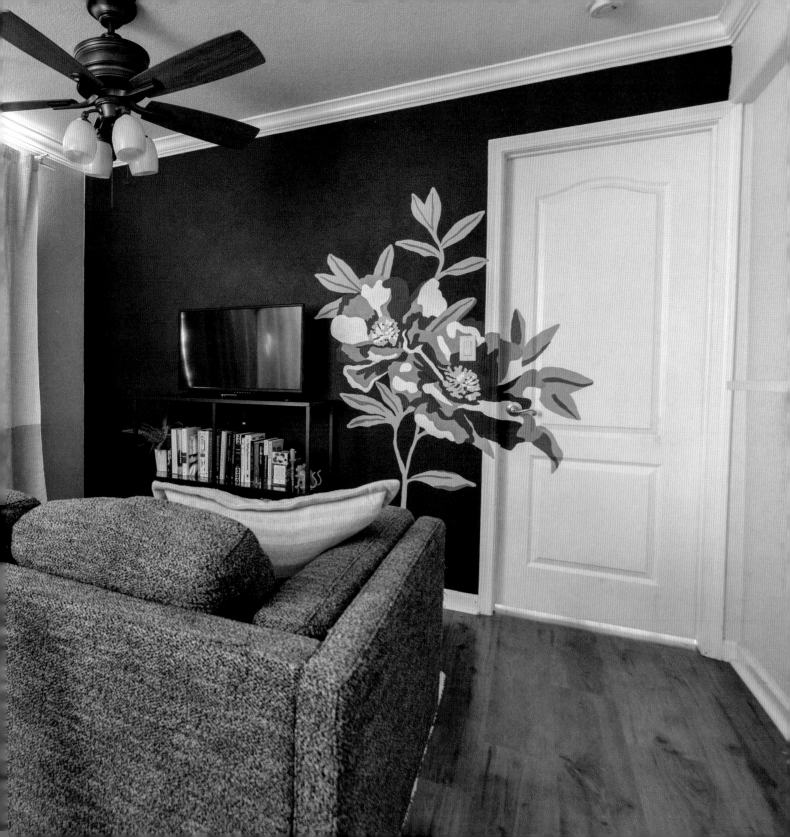

TOOLS

- ☐ 1 drop cloth
- ☐ Projector
- ☐ Downloaded design (see page 202)
- ☐ 8–12 small-to-large brushes
- ☐ Used coffee/soda cups for mixing colors

MATERIALS

- ☐ 1 roll painter's tape
- ☐ Chalk or pencil
- ☐ 1 sample size yellow paint
- ☐ 1 sample size white paint
- ☐ 1 sample size gray paint
- ☐ 1 sample size purple paint
- ☐ 1 sample size black paint

PREPPING

Move your furniture out of the way so you have a clear workspace. Tape off all the areas that you don't want to get paint on. Lay out your drop cloth so that the floor is protected.

TRACING

Turn off the lights in the room and project the image where you would like it on the wall. Depending on the kind of projector you're using, you may have to adjust the distance between the projector and the wall to get the image at the size you want. If your wall is a dark color, outline the floral design with chalk. If your wall is white, outline the design as lightly as possible with pencil.

Projecting and tracing is not a science. The image is always going to look somewhat obscured as you work, so don't spend hours trying to make it perfect. You can always adjust your lines with paint. We also purposely designed these flowers to be shaped somewhat free-form. This will be especially helpful if you have the design go over a doorframe like we did.

1.

Start by painting the yellow and white sections of the flowers and the light gray parts of the leaves. These colors will need the most coats, so it's nice to get them started early in the process.

We recommend working with one color at a time and finishing all of the sections each color appears in before moving on to the next color.

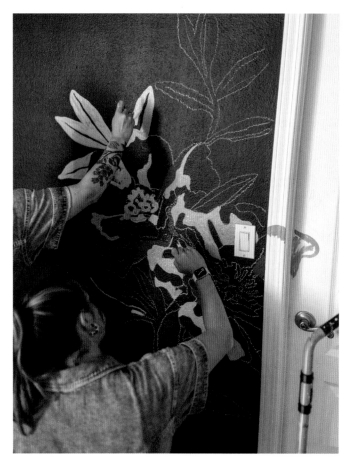

2.

Mix a few shades of purple in your cups, starting with the lightest by using mostly white paint and adding only a tiny amount of purple. Repeat this process but add more purple each time to create your other tints. For the darkest purple, skip the white paint and add a small amount of black paint to the purple instead. We have this broken up into paint by numbers for you, so follow along closely on your download! Use each tint or shade of purple to fill in the appropriate sections on the design. Repeat with each color until you've filled in the full design with enough coats of paint so that all colors appear opaque.

—

If your brushes are drying out in between usage, cover them in plastic wrap. This is an easy way to keep them moist when you're not using them without dipping them in a bucket of water or having to wash them out.

3.

Remove the tape and drop cloth. When everything is dry, put the furniture back in place and snap some photos!

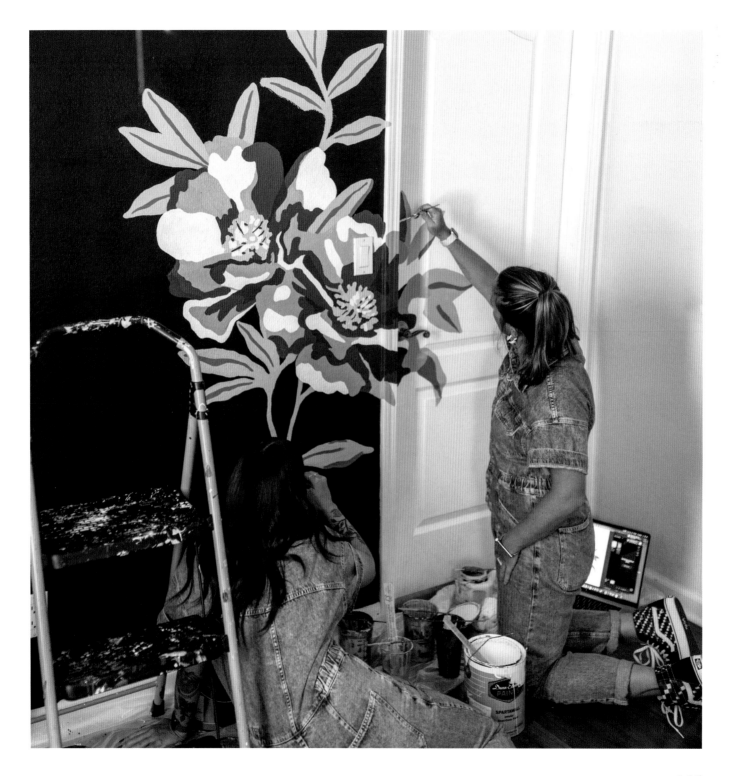

Painterly Ceiling

JUST THE FACTS

SKILL LEVEL: Difficult

TIME: 4–6 hours (not including drying time)

COLORS USED: Green, dark blue, black, tan, turquoise

BEFORE

Why do walls get to have all the fun? Ceilings need lovin' too! (Michelangelo had the right idea.) This project definitely is a statement piece. It's a fun concept, but it won't work for just any home. Where it does work, though, this unexpected design adds a pop of color to the space! We chose our colors to match the artwork already in this room, but you can use whatever colors you like.

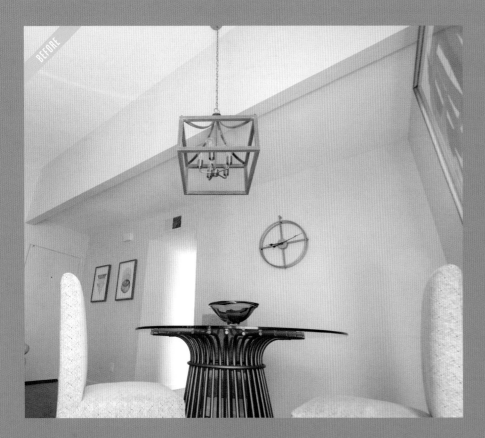

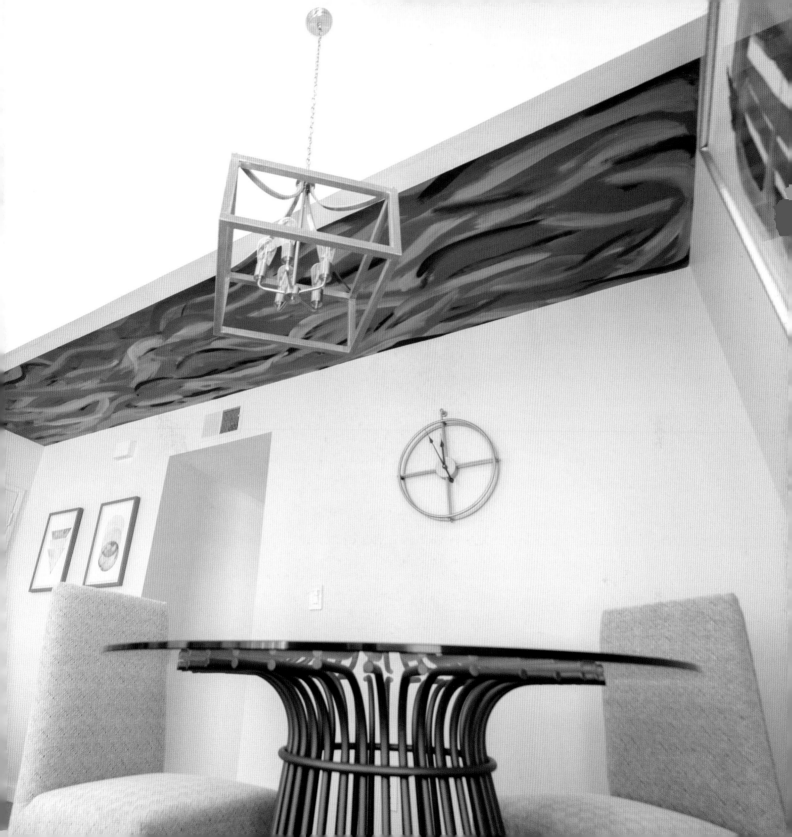

TOOLS

- ☐ 3 plastic drop cloths
- ☐ 5 medium-to-large brushes
- ☐ 1–2 small brushes for touch-ups
- ☐ Ladder

MATERIALS

- ☐ 1 roll painter's tape
- ☐ 1 quart green paint
- ☐ 1 quart dark blue paint
- ☐ 1 quart black paint
- ☐ 1 quart tan paint
- ☐ 1 quart turquoise paint

PREPPING

When you're painting above your head, it's easy to get drips everywhere, so we want you to protect everything and anything that could possibly get paint on it. Move all furniture, tape out the edges of the ceiling, and use a credit card or gift card to smooth out the tape and ensure it is secure. Protect the walls around your ceiling masterpiece by taping plastic drop cloths to the tape around the ceiling. If you want to be extra careful, take down any frames off the walls, even if the plastic drop cloth will cover them. Finally, lay out a drop cloth on the floor to protect where you likely will get the most drips (#gravity).

PAINTING

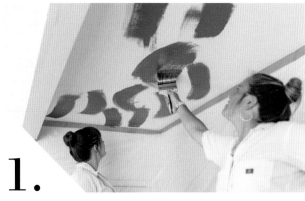

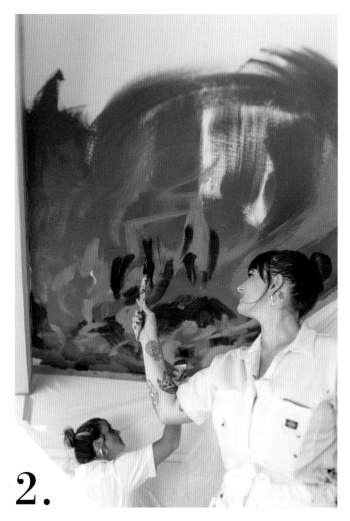

1.

Working with one color at a time, paint rough brushstrokes around the ceiling. Your brushstrokes can go every which way, but should mostly follow the dimensions of the ceiling. Our brushstrokes were 1'–2' long. This design is very loose, so have fun with it. Try not to let yourself get caught up with making everything perfect. The brushstrokes are supposed to look "brushy," and there is supposed to be a lot of movement on the ceiling.

In our case, the ceiling was long and narrow, so we started at one end. We recommend that you do the same.

2.

Once you've added a sufficient amount of your first color, put the brush down and begin with your next. To get the wispy, brushy look, your first paint color should still be wet as you add the next color. Repeat until you've gone through all five colors. If there is a certain area that is bothering you, like if you think there's too much black, wait for it to dry and paint a stroke of turquoise or green on top! The great thing about paint is that it's not permanent, so you can continue to edit your work.

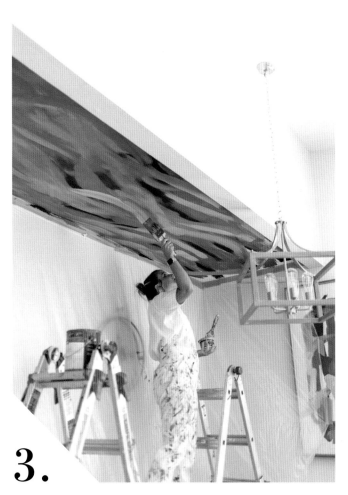

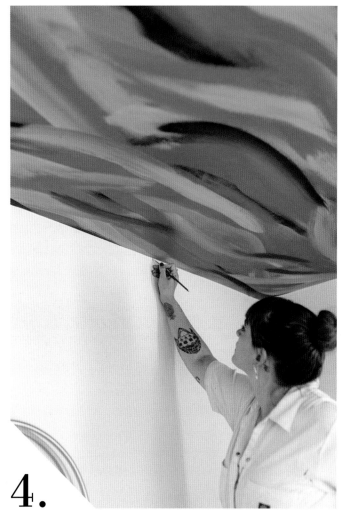

3.

If you'd like to blend some of your colors, paint those colors while they're wet and smudge your brush in between. As you move along the ceiling, keep an eye on your drop cloths to make sure that everything remains covered. Also continue to blend your brushstrokes and keep the movement going.

4.

Remove the tape and use small brushes to clean up the edges as you'd like. Gather your drop cloths, fold up your ladder, put the furniture back in place, and enjoy your finished masterpiece!

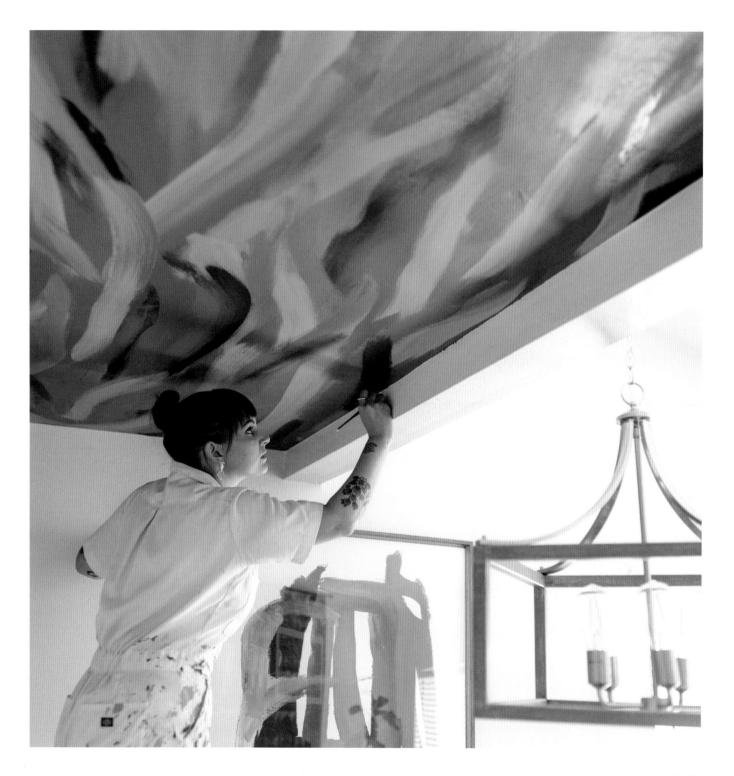

Bar Arches

BEFORE

Don't you just love a good bar? Instead of spending a pretty penny on tile, you can create something even more exciting with paint! We wanted to create a mid-century modern look with this color and design. You might not think this works for your space, but just swapping these colors for something better suited for your room might do the trick!

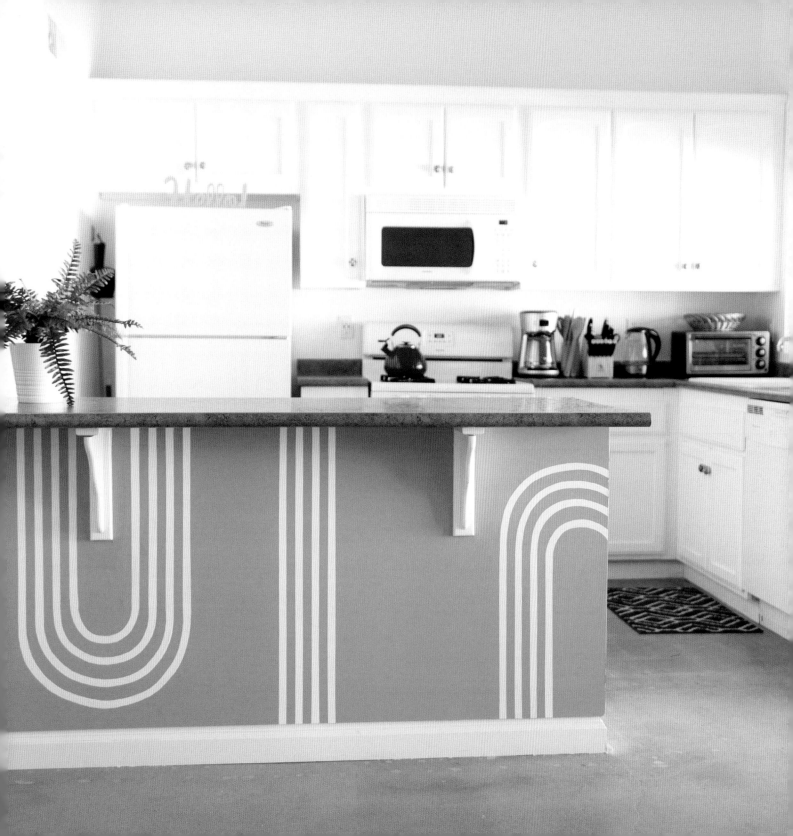

TOOLS

- ☐ 1 drop cloth
- ☐ 3–5 brushes in varying sizes

MATERIALS

- ☐ 1 roll painter's tape
- ☐ 1 quart golden yellow paint
- ☐ Chalk
- ☐ 1 sample size white paint

PREPPING

Tape the edges of the bar, the floor, and anywhere else you don't want to get paint. Lay down your drop cloth to cover the floor.

PAINTING

1.

Paint the background with golden yellow paint or whatever color you chose. Remember to always let the paint dry before you start painting another coat.

2. When the background is fully dry, it's time for the fun stuff! Find the middle of the wall and lay out five evenly spaced pieces of tape for your four center-lines. To ensure that the lines themselves and the spaces between each line are the same width, make the measurement between the lines the same width as your tape.

Since our background is yellow, it took three coats to get the color looking even.

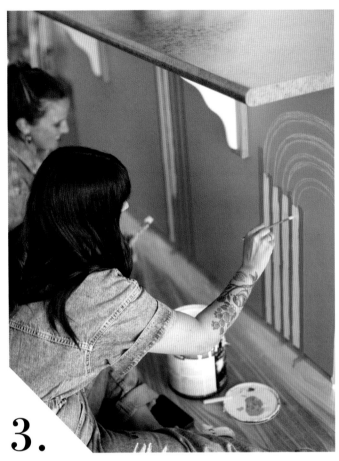

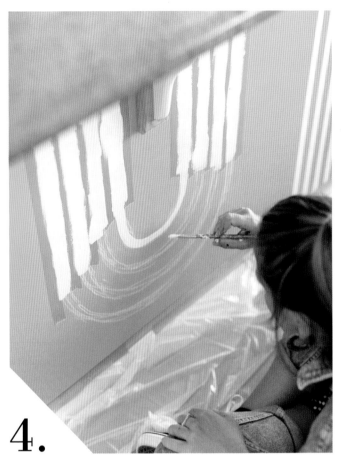

3.

Sketch four evenly spaced arches on the right side of the centerlines. To make perfectly round arches, you can use the string method we describe on page 117 or trace around a mixing bowl if it's the right size. After you have sketched four half circles, extend the lines on either side of each arch. Use your tape to create the straight lines. Step back and check that your lines are straight before you start painting.

4.

On the left side of the centerlines, repeat the process for creating the arches and lines from step 2, only position the arches at the bottom of the lines. Carefully paint the arches with a tiny brush. It's okay if you mess up; you can always use the background color to fix an error.

5.

When you're happy with your arches and lines, remove the tape and clean up your drop cloth. You're all done!

Faux Tile Pattern

JUST THE FACTS

SKILL LEVEL: Difficult

TIME: 5–7 hours (not including drying time)

COLOR USED: Black

BEFORE

Buckle up, because this design requires a lot of measuring and a level. It's not typically our style, but we wanted to show all you line lovers something intricate. This mural is a great alternative to wallpaper or tile, so if you're renting and want a space upgrade, this one's for you!

- ☐ 1 drop cloth
- ☐ Tape measure
- ☐ Level
- ☐ Ruler
- ☐ Step stool or ladder

- ☐ 1 roll painter's tape
- ☐ Pencil
- ☐ 5–10 black Posca paint pens

PREPPING

Remove anything from the space that you don't want to get paint on. Tape along all the edges of the wall, including at the ceiling and trim. Lay down your drop cloth and you're ready to go!

PAINTING

1.

Measure eight even sections across the wall. Use your level to tape down straight lines for each section. Draw a line with a paint pen along the left side of each piece of tape, then remove the vertical strips of tape.

3. Next you're going to measure a series of points on the vertical lines. Starting in the middle of the wall, measure a 12" section on your line (as shown by letter A in the diagram below). On the adjacent vertical lines, measure an 8" section (B) that is centered with the 12" section. Connect those alternating marks with your paint pen and a ruler to create a zigzag line (C). Continue this across the whole wall.

4. Once your zigzag lines are finished, connect the top corner of an 8" line to the bottom of a 12" line, and then back up to the top of next 8" line (D). Repeat across the whole wall, then create a diagonal line (E) in between each of the lines you just made.

2. Measure the midpoint between each of the lines you made in step 1. Use your level to tape straight lines along the left side of those midpoints. With your paint pen, draw a line along the left side of each strip of tape. Remove the tape.

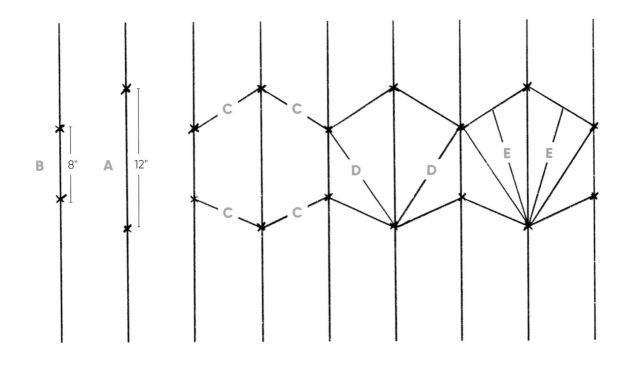

Covering the entire wall this way can be a little bit tedious, so make sure you're taking breaks, having a sip of water, and sending pics to your bestie along the way.

5. When you've covered the whole wall with the tile pattern, step back and admire your handiwork!

Colorful Mosaic

BEFORE

Who says you can't have fun with your bathroom?! We wanted to show that any space, no matter how small, can have a complex, colorful mural in it. This one is all about shapes. We think of it as a 1980s geometric design without all the neon. It's clean, it's classy, and it's a little challenging. So if this is your first time picking up a paintbrush, maybe choose a project that's a little simpler. Unless you like a challenge and proving people wrong, then by all means . . .

This design will take a bit of improvisation on your part. The key is making it fit in perfectly with your unique space. Have fun with it!

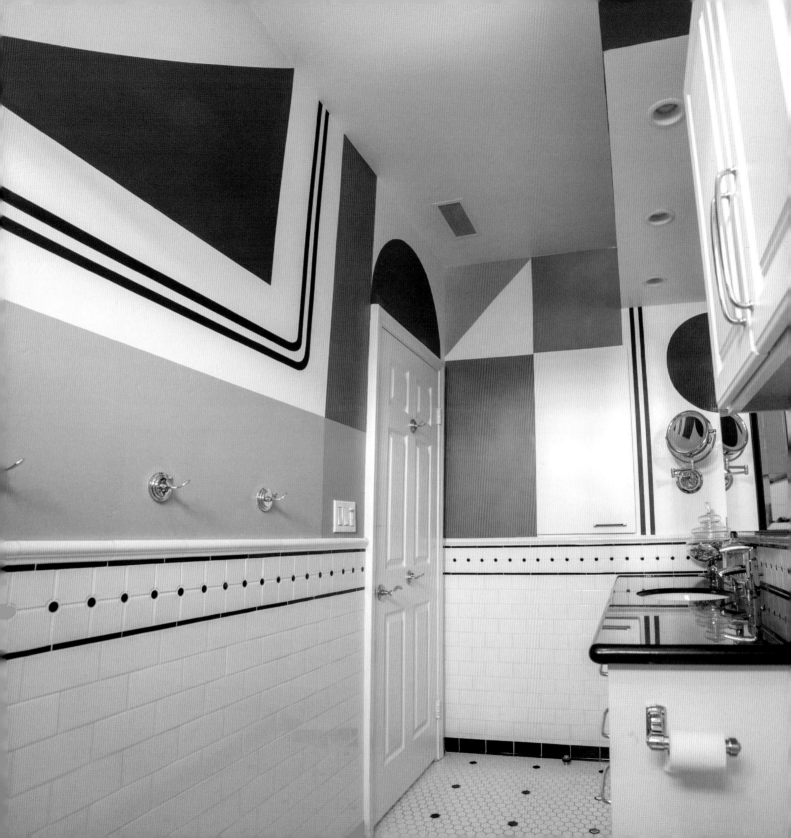

TOOLS

- ☐ 1 drop cloth
- ☐ Brushes in varying sizes
- ☐ Ruler or level
- ☐ Shoelace or piece of string
- ☐ Step stool or ladder

MATERIALS

- ☐ 1 roll painter's tape
- ☐ 1 gallon white paint (if you need to paint the background)
- ☐ Chalk or pencil
- ☐ 1 quart paint of each color

PREPPING

Tape off anything you don't want to get paint on and lay down your drop cloth. If your wall is already white, lucky you! You don't have to paint the background. Otherwise paint the background white and let that baby dry!

PAINTING

1. With your pencil, ruler, and tape, lay out the design you want. Tape out triangles, squares, and stripes around your walls. You can follow our pattern or create something different.

We wanted a variety of shapes and sizes and a decent amount of negative space. We also used the string method described on page 117 to create a half circle above the door and next to the mirror.

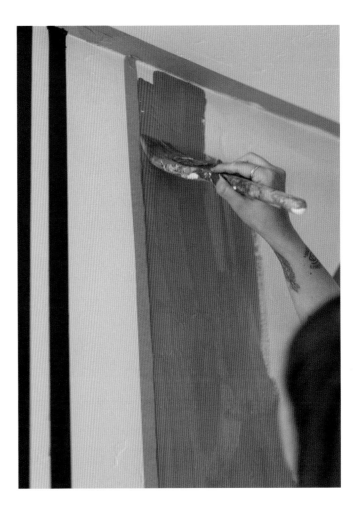

2.

Decide which color you want in each spot. Make sure you have a balance of each color you are using, then start painting in each shape. Paint one color at a time and let each dry before adding more coats. Once you get a look that you like, clean up and relax! You deserve it!

We like to dab a little paint on each shape so we remember which color goes where. We started painting our large block on the bottom left corner.

Desert Scene

JUST THE FACTS

SKILL LEVEL: Difficult

TIME: 4–5 hours (not including drying time)

COLORS USED: Blue, white, brown, orange, red, black

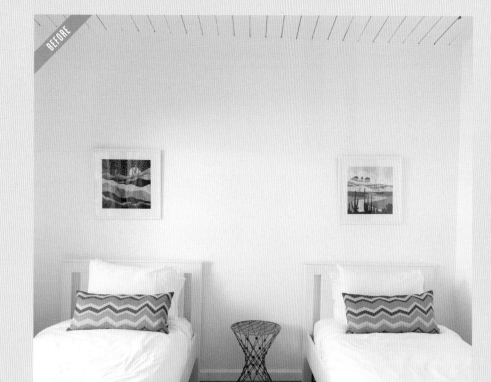

BEFORE

Bring the outdoors inside with this beautiful mural. It'll create a sense of depth and energy in the room, even if the space is small! We went with the desert theme because the house was in Palm Springs, California, but feel free to change the colors and paint a scene of a greener place. We encourage you to use our projects as a jumping-off point and get as creative as you want.

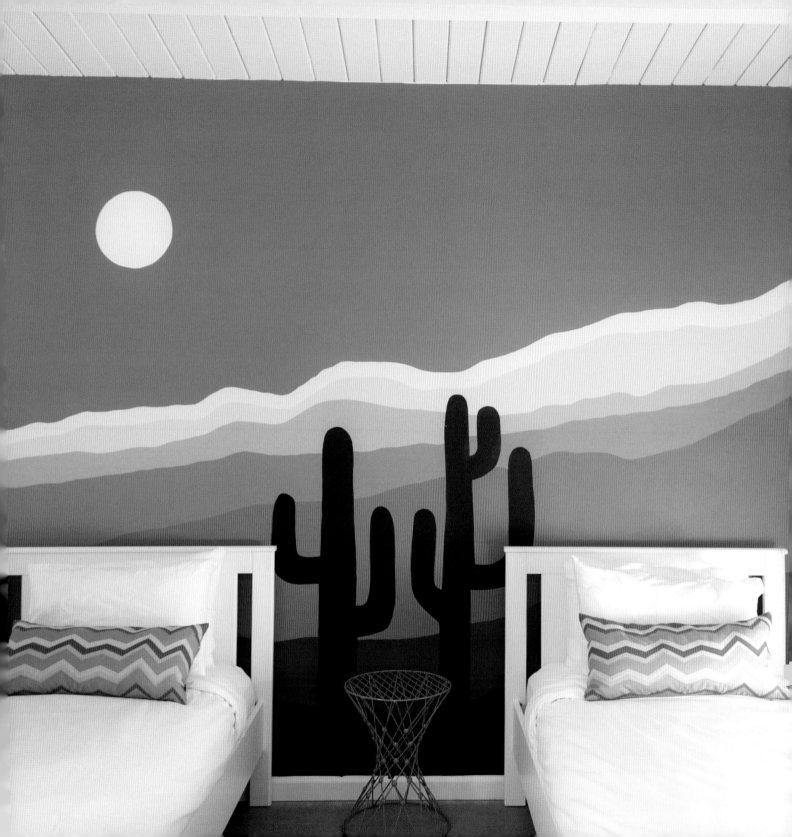

TOOLS

- ☐ 1 drop cloth
- ☐ Tape measure
- ☐ 1 salad bowl (for tracing the moon)
- ☐ 8–12 small-to-large brushes
- ☐ Used coffee/soda cups for mixing colors
- ☐ Step stool or ladder

MATERIALS

- ☐ 1 roll painter's tape
- ☐ Chalk or pencil
- ☐ 1 quart blue paint
- ☐ 1 sample size white paint
- ☐ 1 quart brown paint
- ☐ 1 quart orange paint
- ☐ 1 quart red paint
- ☐ 1 quart black paint

PREPPING

Tape off the ceiling, floor, and anything else in the area that you don't want to get paint on. Lay your drop cloth on the ground.

SKETCHING

1. Decide where on the wall you want the mountain peaks to hit, and whether you want the cacti (or any other element) to be centered horizontally. Since our room had two beds, we centered the cacti, but if you have one bed (or another single piece of furniture) in the middle of the room, place your cacti off to the side. Start your sketch with the outlines of the mountains because those will dictate the placement of everything else. The mountains should progress from a lower altitude to a higher altitude, finishing a few feet higher on the right-hand side than where you started on the left-hand side. Then sketch out the silhouette of each cactus; don't worry about the shape being perfect.

We wanted the mountains to be well above where the headboards hit the wall, so we made sure to measure the height. In total, we wanted the mountains to be made up of seven gradient layers. You can use more, or fewer, colors in your mountains. We also wanted the cacti to go in the middle of the twin beds, so we marked those spaces as well.

PAINTING

1. Fill in the sky area with blue paint. If it needs an additional coat or two, wait for the paint to dry before applying the new layer.

2. Mix three different tones of brown/cream. Start with a mixing cup of white paint and add a tiny bit of brown paint. This will be the color for the top layer of the mountain. Mix the colors for the second and third mountain layers in separate cups, again starting with white paint and adding slightly more brown paint in each cup.

2.

Trace your salad bowl or whatever you have lying around (maybe a frying pan!) to create the moon shape.

Our wall started off white, so we were able to leave this negative for the moon.

3.

Dab a small amount of paint into each section of the sketch to help you keep track of which color goes where, starting with the lightest color at the top of the mountain. After your three brown tones come orange, then red, then black at the base. This will create a gradient effect. Also dab the cacti with black paint.

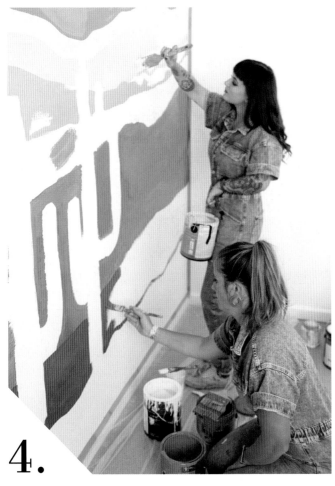

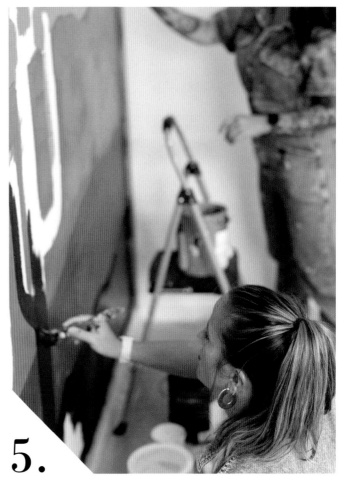

4.

Paint your lightest color first because it likely will need a few coats. Then paint your second layer beneath the lightest one and so on. Outline the general shape of each layer with a smaller brush, then fill in the larger surface area with a larger brush. You can be a little messier with the layers of the mountain around the cacti because the black paint will cover up everything else. It's easier to paint a black cactus over the mountain colors than vice versa.

———

In our experience, the orange and red always require the most coats.

5.

Continue to fill in your color blocks until the paint looks opaque. Touch up uneven edges with tiny brushes, but keep in mind that we designed the mountain range to be uneven and organic, so don't worry about straight edges there!

6.

While the paint is drying, carefully start taking off the tape. Pack up your paint cans and move them to the side. Wrap up the drop cloth and, once the paint is fully dry, put the furniture back in place.

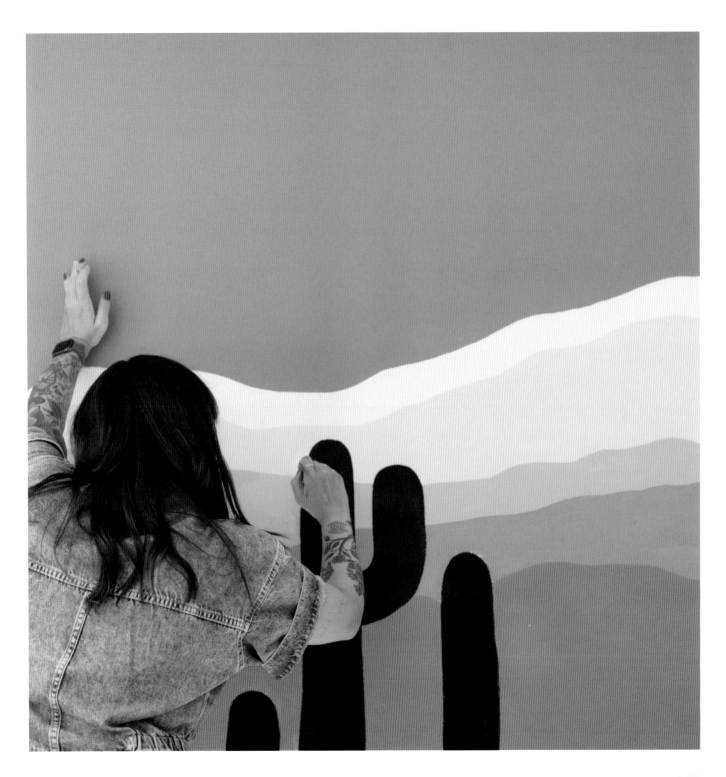

Cotton Candy Watercolor

JUST THE FACTS

SKILL LEVEL: Medium

TIME: 1–2 hours (not including drying time)

COLORS USED: Light pink, light blue, white

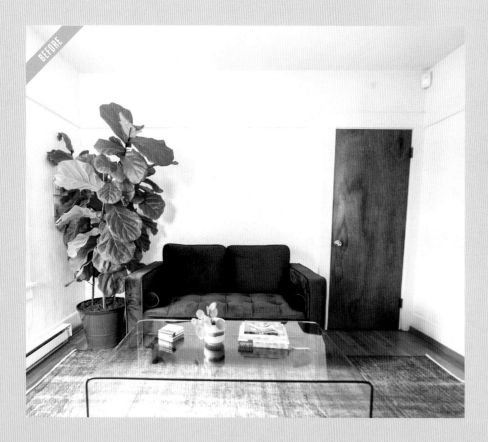

BEFORE

Do you love cotton candy? How about watercolor? This project gives you total cotton candy watercolor vibes. It's a fun one to do and will give your space a unique and airy feeling! We guarantee you'll get compliments from anyone who comes over.

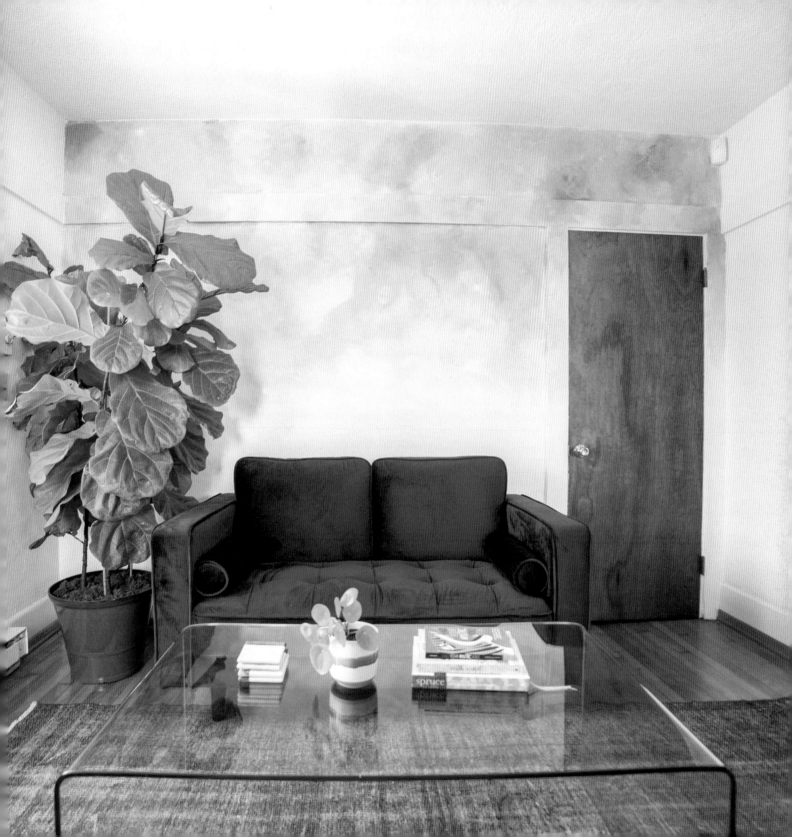

TOOLS

- ☐ 1 drop cloth
- ☐ 3 medium-to-large brushes
- ☐ Rags
- ☐ 1 bucket (for holding water)
- ☐ Step stool or ladder

MATERIALS

- ☐ 1 roll painter's tape
- ☐ 1 quart light pink paint
- ☐ 1 quart light blue paint
- ☐ 1 quart white paint

PREPPING

Remove your furniture and anything else that might get in the way of you painting your masterpiece. Lay down your drop cloth, then tape the edges of the wall, including the ceiling. In this mural design, the watercolor effect fades from the top of the wall to the bottom, so you don't need to tape off the bottom trim. Where you do tape, rub it with a credit card or gift card to ensure it is fully secured to the wall.

PAINTING

1. Use brushes to make pink and blue blobs about 2'–3' long, near the ceiling. Work your way across the top of the wall by alternating between pink and blue, and occasionally adding in some white paint. With a dampened rag, rub adjacent colors together. The colors blending with the white paint helps create the watercolor look.

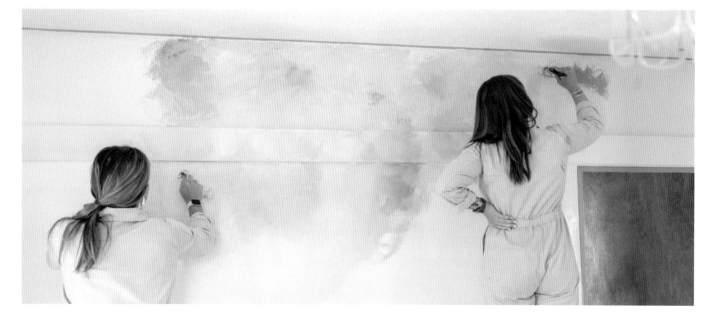

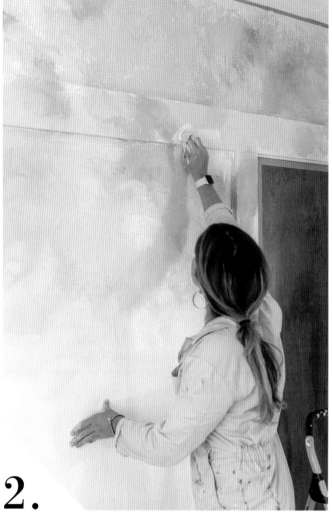

2.

Continue working in this way down the wall. Brush on big blobs of your color, then blend with the white paint and damp rag. The white will give the effect of being see-through. You're going for a soft look, so try to blend wherever possible so there are no hard edges. Don't be afraid to get messy with this one either; you're definitely going to get paint on your hands! As you approach the midway point of your wall, begin to add more and more white. You want the cotton candy to fade out and slowly disappear. Blend more, add white, and take a step back. How does it look? Still too harsh? Add more white and more water!

3.

Peel off the tape, clean up, and put back all the furniture.

If your wall, like ours, is textured, you'll need to push hard with your dampened rag so that you get the mixed paint into the holes and creases of the wall.

Imperfect Diamond Pattern

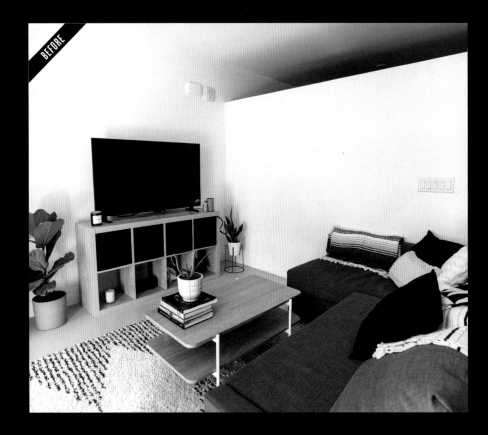

BEFORE

Not everything has to be perfect and polished. Sometimes, giving something an imperfect look can make it appear more upscale and artistic. That's why we love this design. It gives you the freedom to make the shapes whatever size you want and to place them wherever you want. If you have perfectionists in your life, this mural might stress them out!

We decided to make this mural black and white to keep in line with the room's existing decor, but you might want to use some color. We chose a rich black background to help the space feel bigger (white walls can make a space feel sterile and empty), and we positioned the left side of the mural at an angle to draw the eye upward and further help the piece feel bigger, but not too overwhelming. You can create your version on one wall or paint it over two walls like we did.

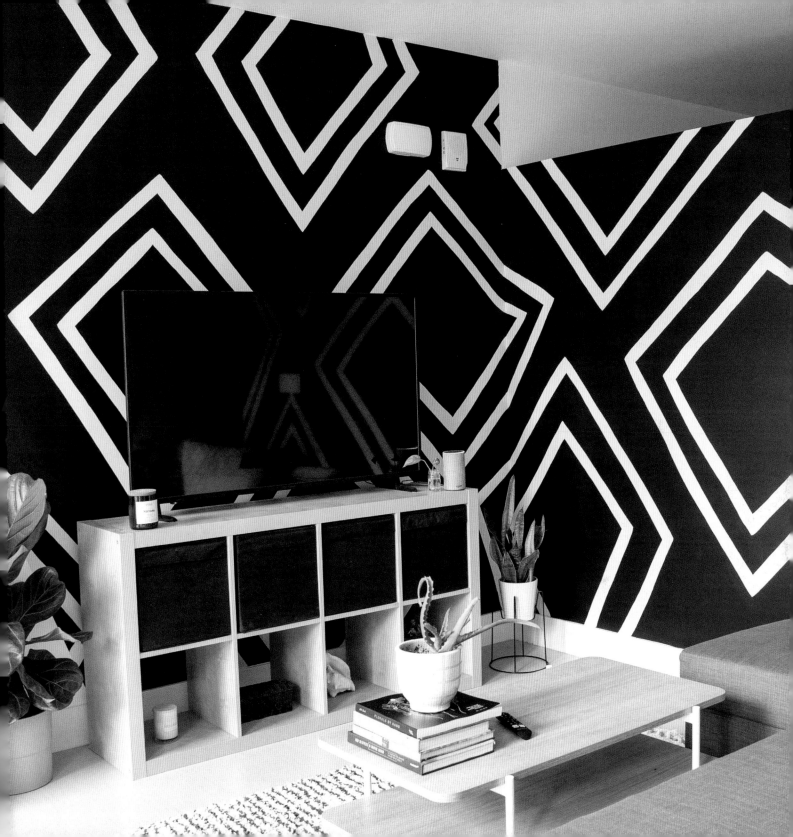

TOOLS	MATERIALS
☐ 1 drop cloth	☐ 1 roll painter's tape
☐ Tape measure	☐ Chalk
☐ 3–4 brushes in varying sizes	☐ 1 gallon black paint
☐ Roller and tray	☐ 1 quart white paint
☐ Step stool or ladder	

PREPPING

1. Move any furniture out of the way. Tape off all the edges of your mural, including window and door frames, the ceiling, and anything else that you don't want to get paint on. Lay down a drop cloth to protect the floor.

2. Creating an angle on the edge of the mural can help make the space feel larger than it is, as long as the slant isn't too drastic. We aligned the bottom left-hand edge of this mural with the outside edge of the TV console, and set the top left-hand edge of the mural 2' in from the edge of the wall. You might want to position your angle a bit differently depending on the size of your wall and the furniture in your space. If you're not sure how to decide, we suggest a 2½' difference between the top and bottom edges of your mural to create a nice angle.

—

Use a credit card or gift card to push down your tape to get perfect, clean lines.

PAINTING

1.

Paint the mural background with black paint, starting with a 2" or 3" brush for the edges and any awkward spaces you can't reach with a roller. Then fill in the rest of the wall with a roller. Make sure you don't get too much paint on your roller to avoid paint splatters and drips.

Once the background is filled in, sit back and relax while the paint dries. Then paint a second coat. (Depending on the color you're using, you might be able to get away with one coat, but better safe than streaky! And depending on the paint brand and specific color, you might even have to do three coats. Stay away from yellows or reds if you want to avoid this.)

2.

Now comes the exciting part: the pattern! Measure your wall and make a small tick mark with chalk at the vertical and horizontal centers. These will act as guides for you as you work on the rest of the design.

Then, starting from the center of the wall and working your way outward, chalk out all of the diamond shapes, one inside the other. To create a balanced design, keep about the same amount of space between the shapes. Remember, this is supposed to be a little free-form and imperfect, so don't be afraid to play around with the design. If you "mess up" at this point, you can just wipe the chalk off and start over. If you want to play up the imperfect vibe, you can vary the sizes of the diamonds, but it's best not to go too extreme.

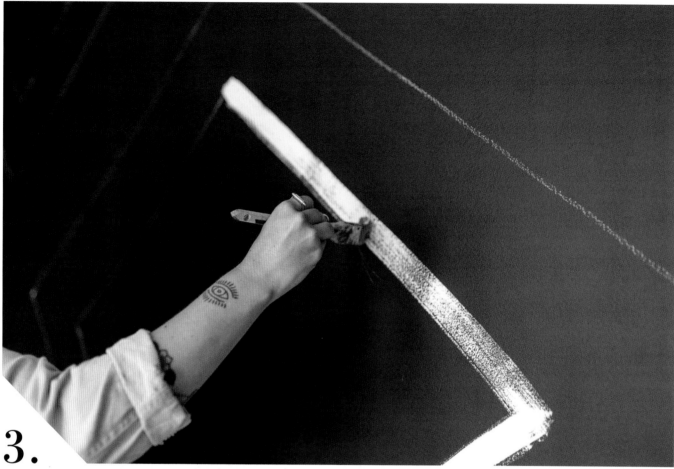

3.

Paint the diamonds with white paint. If you want, you can keep your strokes very brushy (like we've done) or paint a couple coats to get a uniform thickness. If you decide to do multiple coats, wait for the first coat to dry fully before painting the second coat. Also, make sure to have your background color handy in case there are any drips!

4.

When your mural is looking perfectly imperfect, remove the tape and clean up the space while you wait for the final coat to dry. Once you've put the furniture back in place, take a moment to look at your handiwork and remind yourself that you're capable of anything!

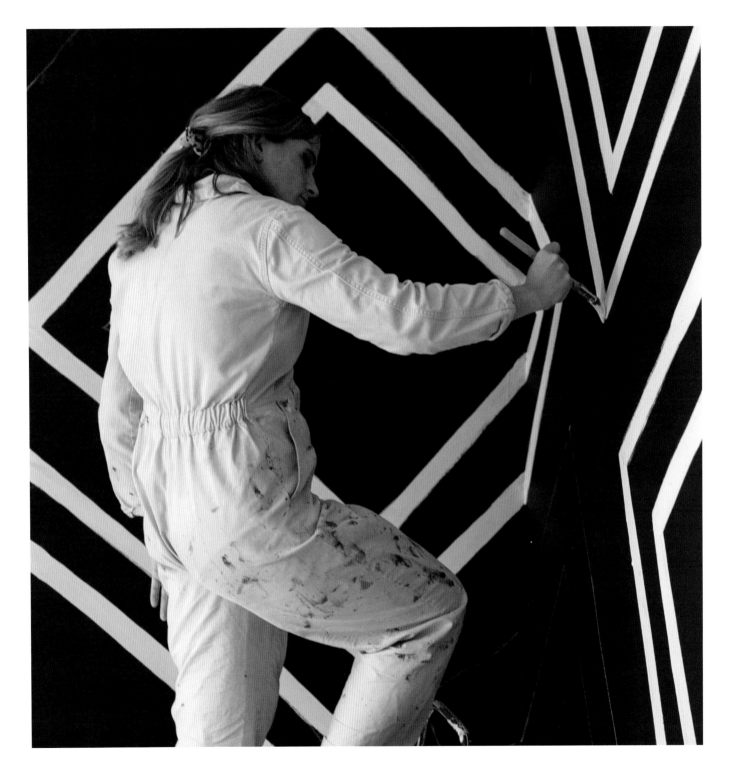

Rainbow Grid

JUST THE FACTS

SKILL LEVEL: Difficult

TIME: 3–4 hours (not including drying time)

COLORS USED: Magenta, red, orange, yellow, green, white

BEFORE

The rainbow grid is a showstopper. We love this design and you will, too. It's not for every wall, but when applied as a statement piece, it will completely transform the room. Not a rainbow fan? No problem. Switch out your colors to customize it to your liking.

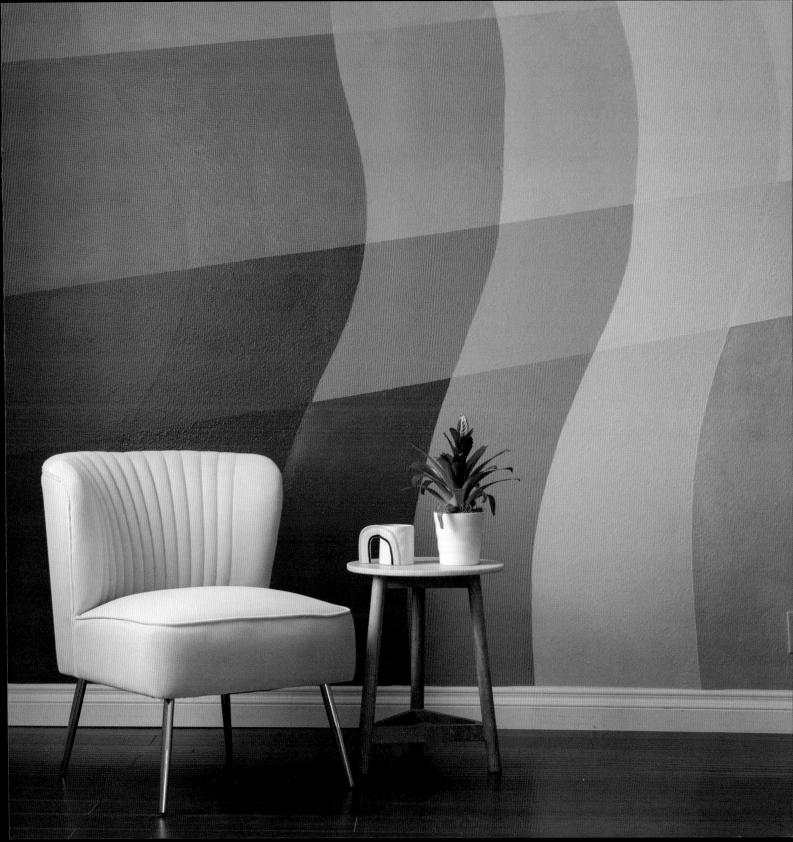

TOOLS

- ☐ 1 drop cloth
- ☐ 10–15 small-to-medium brushes
- ☐ Used coffee/soda cups for mixing colors
- ☐ Step stool or ladder

MATERIALS

- ☐ 1 roll painter's tape
- ☐ Chalk or pencil
- ☐ 1 quart magenta paint
- ☐ 1 quart red paint
- ☐ 1 quart orange paint
- ☐ 1 quart yellow paint
- ☐ 1 quart green paint
- ☐ 1 quart white paint

PREPPING

Move your furniture out of the way and create an open space on the floor so that you can lay out all your supplies. Tape the trim, ceiling, and anything else touching the wall that you want to protect from paint. Then put down a drop cloth to protect the floor. This project uses a lot of color, but let's keep it on the wall and not on your furniture.

SKETCHING

1. Start by dividing your wall into four horizontal sections with tape. These sections can be equally sized or varied. Smooth out the tape by rubbing a credit card or gift card over it.

2. Use chalk or pencil to divide your wall vertically into six sections, drawing five wavy lines from the ceiling to the floor. Just like the horizontal sections, the vertical sections do not have to be equal in size. This mural is meant to be whimsically imperfect.

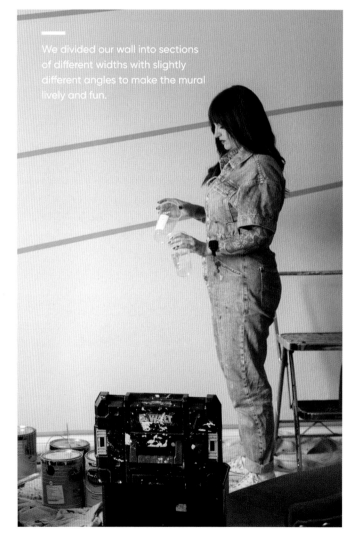

We divided our wall into sections of different widths with slightly different angles to make the mural lively and fun.

PAINTING

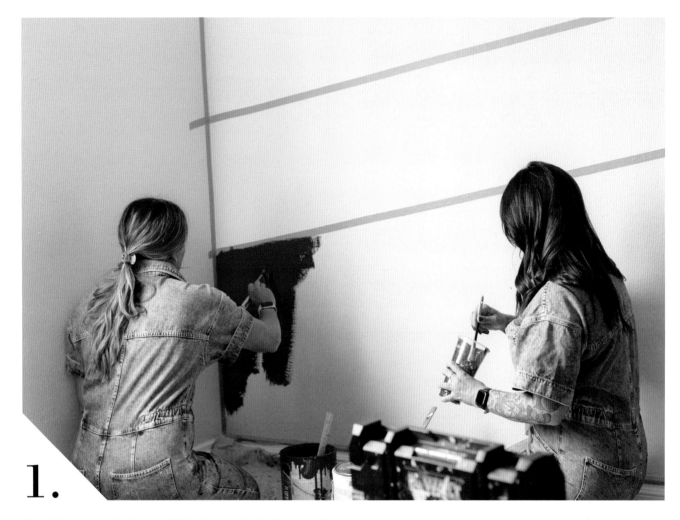

1.

Now it's time for the fun part! Starting at the bottom section of the wall and moving from left to right, paint each segment a different color, in rainbow order. Mix together the red and orange paints in a cup to get the exact color you want for your third segment.

We began with magenta, then moved to red, red-orange, orange, yellow, and green.

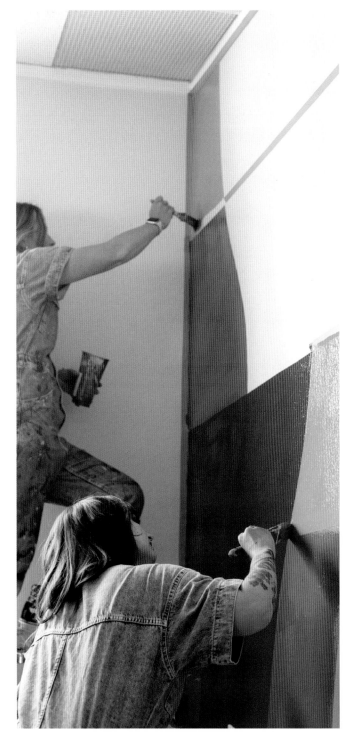

2. When that lowest level is complete, remove the bottom section of tape to reveal the clean line and full squares above. Stir in a tiny bit of white paint to each original color in your cups. Work your way again from left to right, painting each segment in this layer a slightly lighter tint of the color below it. Work slowly and carefully along the edges between segments to ensure clean, straight lines.

You are creating a vertical gradient effect, so each level up will include more white paint.

3. Repeat step 2 until you reach the top of the wall. If necessary, add more coats until each segment is opaque, letting the paint dry in between layers.

4. Remove the tape around the trim and ceiling. Use a small brush to touch up any spots that may need to be fixed. Wrap up your drop cloth and put your furniture back in place. Hooray, you did it! You now have a beautiful mural to brighten up your space.

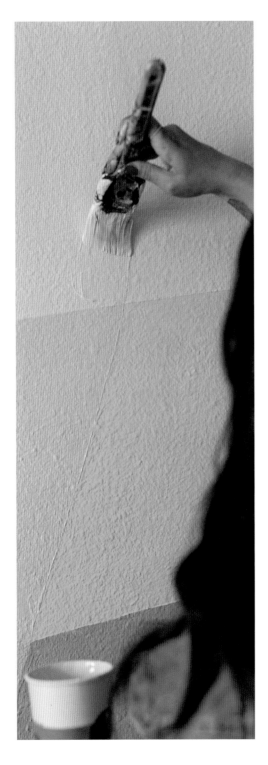

CHAPTER FIVE

Off the Wall Projects

We've already shown you 22 completely different ways you can customize your walls, but paint doesn't have to be limited to walls. Here are four other ways to add creativity to your home without working on a wall.

Mailbox Glow Up

BEFORE

If you're looking for a really quick and easy project, try giving your mailbox a makeover! We've painted the mailbox outside our office a few times, and we always use this as our point of reference when someone comes to visit: "It's the one with the colorful mailbox; you can't miss it!"

This project uses a tracing technique, so make sure you can download and print out our *hello* design. If you're new to this tracing technique, watch out! It will open a ton of doors for your creativity. Oh, and since you'll be working on a much smaller scale than a wall, make sure you have a few tiny brushes at your disposal.

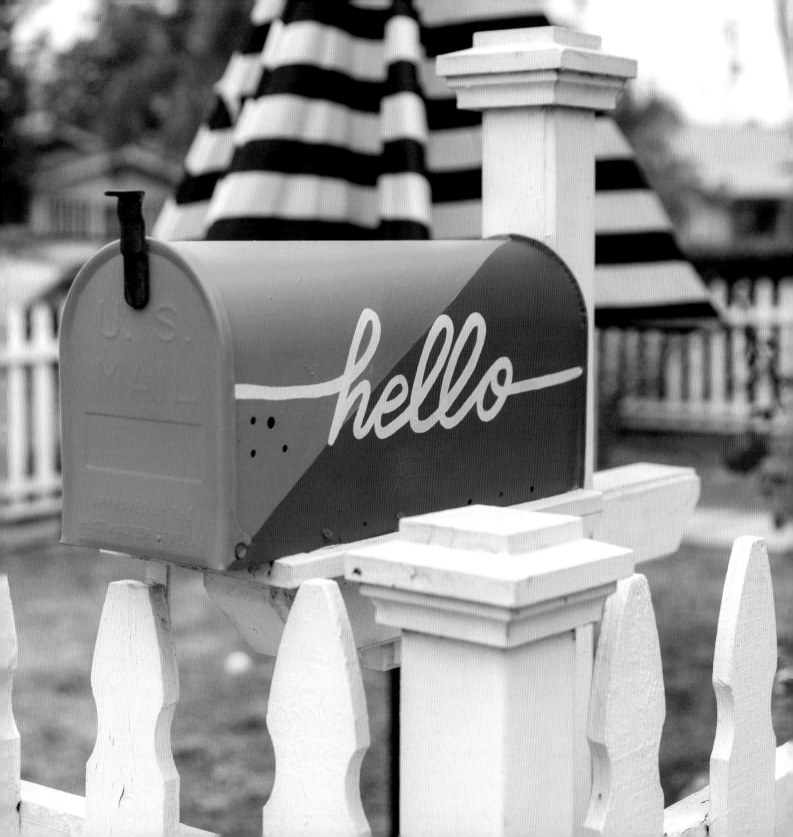

☐ 1 drop cloth

☐ 3–5 brushes in varying sizes

☐ Mailbox

☐ 1 roll painter's tape

☐ 1 quart dark blue exterior paint

☐ 1 quart light blue exterior paint

☐ 1 printout of the *hello* design
(see page 202)

☐ Chalk

☐ Pencil

☐ 1 sample size white exterior paint

PREPPING

Use tape and a drop cloth to cover everything that you don't want to get paint on.

PAINTING

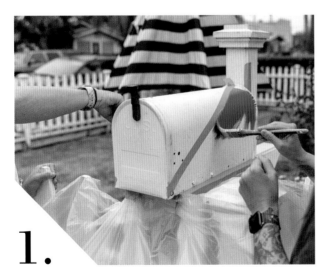

1.

This design includes a cute triangle pattern, so first tape a diagonal line on each side of the mailbox from the bottom front corner to the center top of the back of the box. Fill in both of those sections with dark blue paint. Let the paint dry. If it needs a second coat, paint it again.

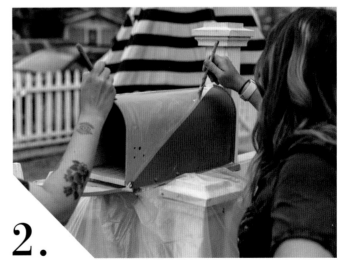

2.

Remove the tape and paint the rest of the mailbox surface light blue. This color probably will need an extra coat or two, so remember to let it dry before you start repainting.

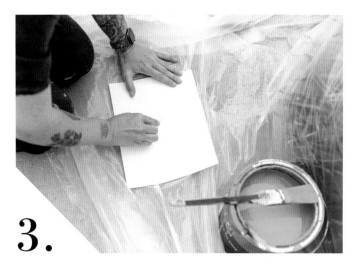

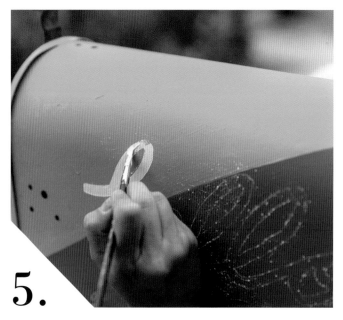

3.

If you don't have your printout of the *hello* lettering, print it out now. Flip over the paper and cover the entire back of the sheet with chalk. Make sure you fully cover the area on the page opposite the letters.

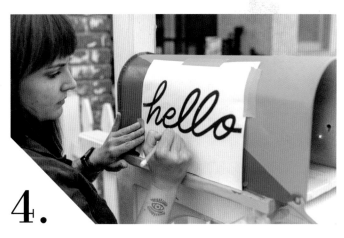

4.

When the mailbox paint is fully dry, position the *hello* exactly where you want it to be and then tape down the paper with the chalk side facing the mailbox and the lettering facing you. Outline the entire word *hello* with a pencil. When you pull up the paper, there should be a nice outline of the lettering to use as your guide. Fully cover the back of the paper with chalk again, then repeat the taping and outlining process on the other side of the mailbox, making sure the words line up.

5.

With a small brush, start filling in the lettering with white paint. Be patient and work slowly. And keep in mind that you have the background color paints, so you can always do touch-ups if you make mistakes. If you need to do a second (or third) coat, remember to let the paint dry in between.

Wild Welcome Mat

JUST THE FACTS

SKILL LEVEL: Medium

TIME: 1–2 hours (not including drying time)

COLOR USED: Black

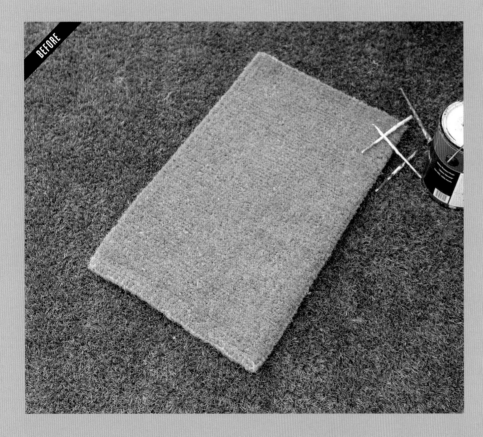

BEFORE

Take a break from painting walls and try out this simple but fun project! All it takes is a basic doormat (we got ours online, but you can purchase yours from just about any hardware store). We wanted to create something custom for our front door and we went with this leopard print design, but feel free to use your imagination and paint a different kind of pattern.

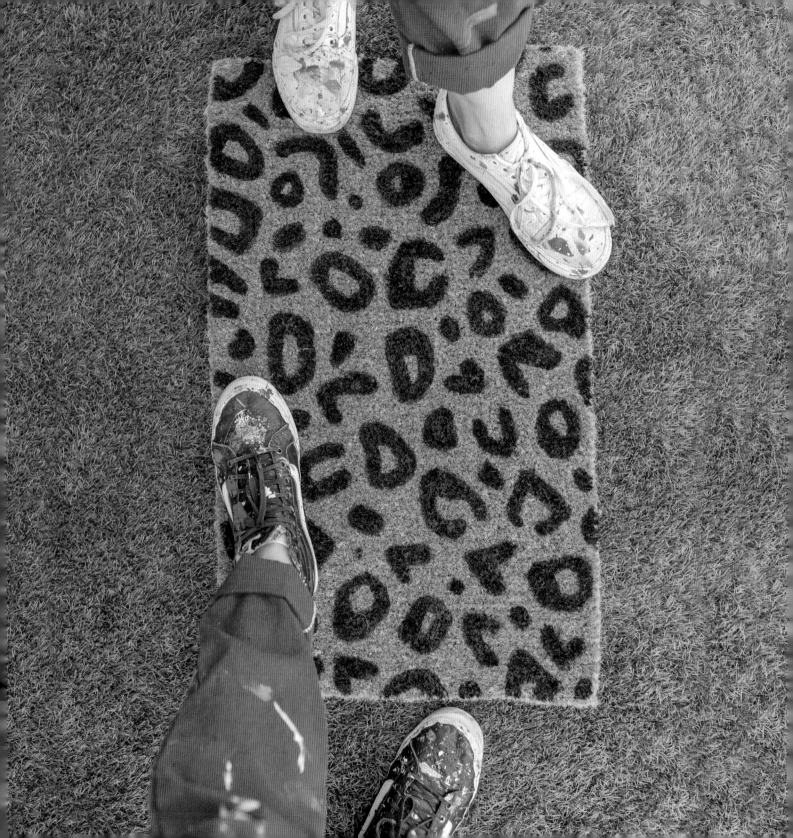

TOOLS

- ☐ 1 drop cloth
- ☐ 1–2 brushes in varying sizes

MATERIALS

- ☐ 1 plain doormat
- ☐ 1 printout of the leopard print design (see page 202)
- ☐ 1 sample size black exterior paint

PREPPING

There's not much prep that needs to happen for this project, and we like it that way! Lay down a drop cloth of sorts to protect the floor or countertop or wherever you're working. We painted ours outside on grass, so we skipped the drop cloth.

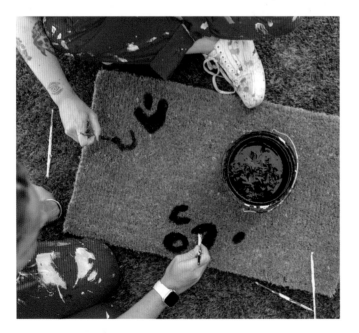

PAINTING

1. Leopard print is essentially a bunch of imperfect blobs, polka dots, and *U* shapes. With a small brush, start painting the pattern on one side of the mat and work your way across. The paint likes to hang out on the top layer of the mat, so be sure to push down somewhat hard on your brush to get the paint to soak in.

We created our leopard print freehand, but feel free to reference the pattern we included. It's important to have some of the pattern bleeding off the edges.

2. Once you've filled the entire mat, touch up any bits of paint that don't seem opaque. Leave your mat somewhere safe to dry for an hour or two, and then put it outside your door. You'll get compliments immediately!

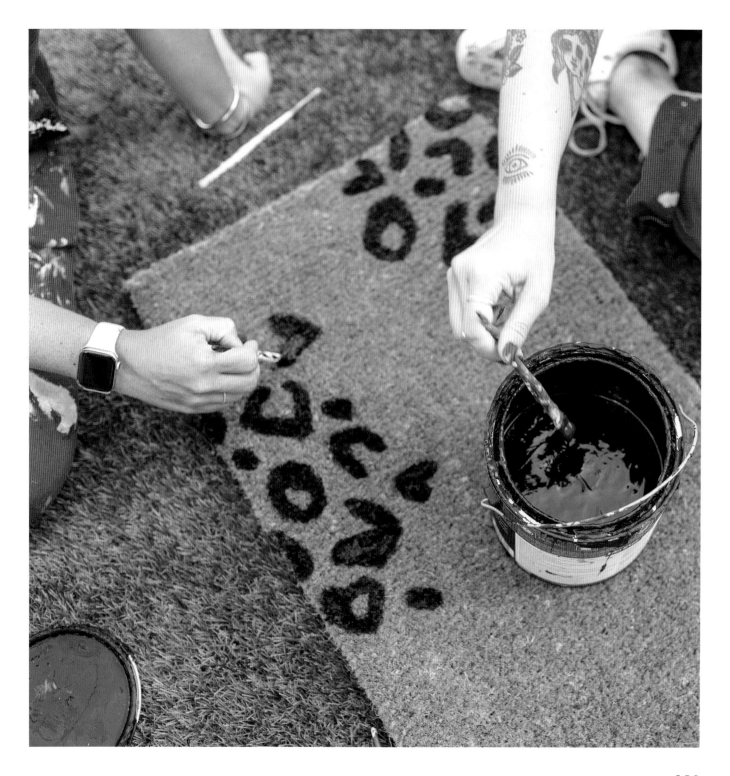

Chair with Flair

JUST THE FACTS

SKILL LEVEL: Medium

TIME: 3–5 hours (not including drying time)

COLORS: Blue, red, fuchsia, coral

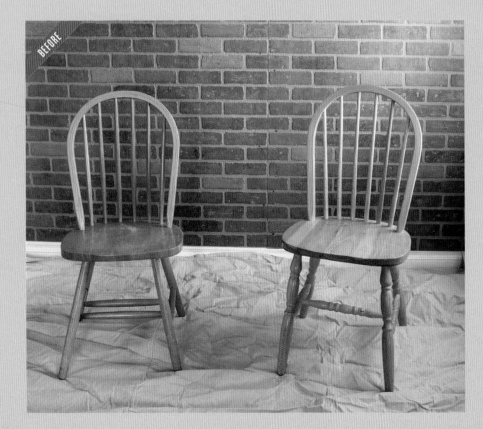

BEFORE

Paint doesn't have to be limited to your walls. If you're nervous about painting something big, start with something less permanent, like furniture! In this project we show you how to turn basic, boring chairs purchased on Craigslist into colorful statement pieces for your dining room. We chose four paint colors and swapped up the placement of each color on each chair, but you can make your chairs more uniform if you're into that.

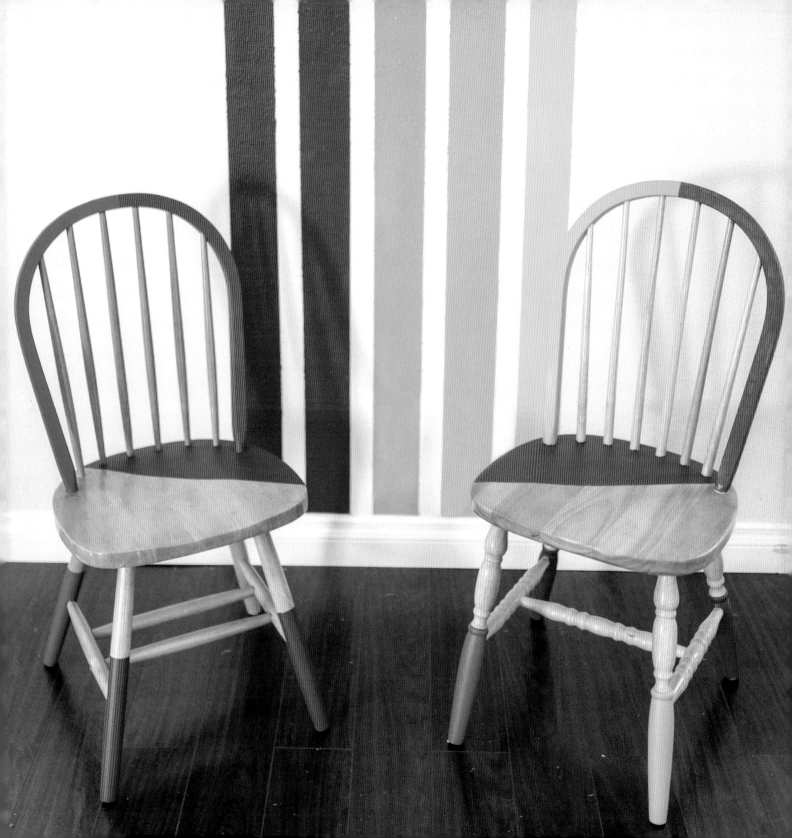

TOOLS

- ☐ 1 drop cloth
- ☐ 5–7 brushes in varying sizes
- ☐ Lint-free cloth

MATERIALS

- ☐ 2 wooden chairs
- ☐ Liquid sandpaper
- ☐ 1 roll painter's tape
- ☐ 1 quart paint of each color
- ☐ Clear, protective topcoat such as Polycrylic

PREPPING

In a well-ventilated area, lay down a drop cloth and place your chairs on top of the cloth. Apply liquid sandpaper with a paintbrush all over the full surface of both chairs. (We use a liquid sander de-glosser, which brushes on quickly and removes any finishes.) Let it soak in for about 15 minutes, then wipe it off with a lint-free cloth.

PAINTING

1.

Apply a piece of tape around the center of the chair's top rail. Paint half of the top rail one color.

2.

Secure a piece of tape around the center of each leg, making sure that your tape placement is the same on each leg. (We don't want your chair to look lopsided!) Paint the bottom of each leg a different color.

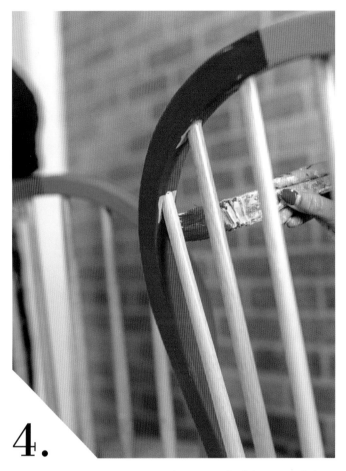

3.

Place a piece of tape diagonally across the seat of the chair, making sure to create the same angle on each chair. Fill in the back portion of the seat with color, using a tiny brush to get in between the bars of the chair. Depending on the color you're using and the furniture finish, you might need to paint a couple coats to get a nice rich color.

4.

Once you're happy with the color, take off all the tape. Paint the remaining side of the top rail. When the paint is fully dry, coat the chairs in a clear sealer to protect the paint from getting damaged or peeling off. Once the sealer has dried, take a seat and enjoy your efforts!

———

The sealer we recommend can be purchased in a spray bottle or applied with a brush.

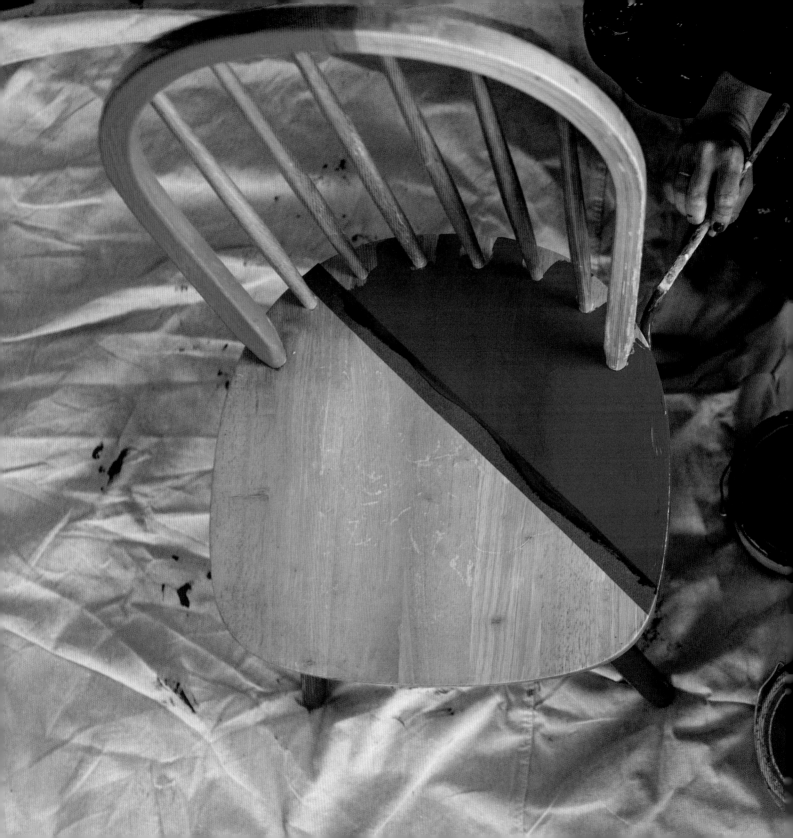

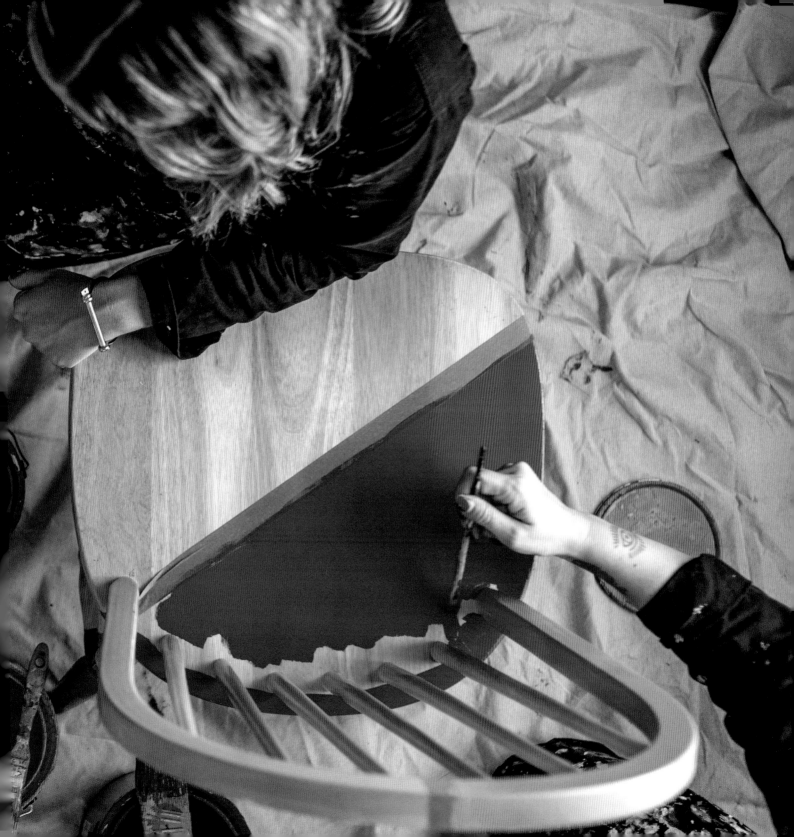

Wood to Wow Tray

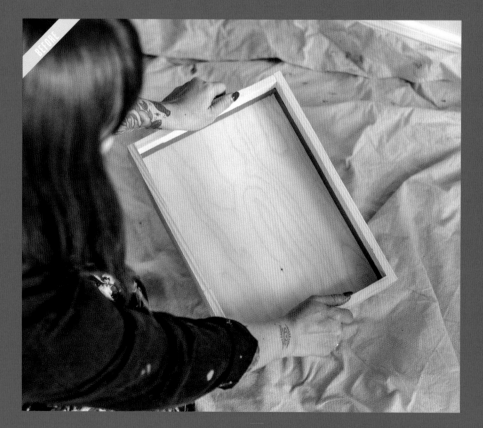

BEFORE

In this simple project, we'll show you how to turn a plain wooden tray into something chic!

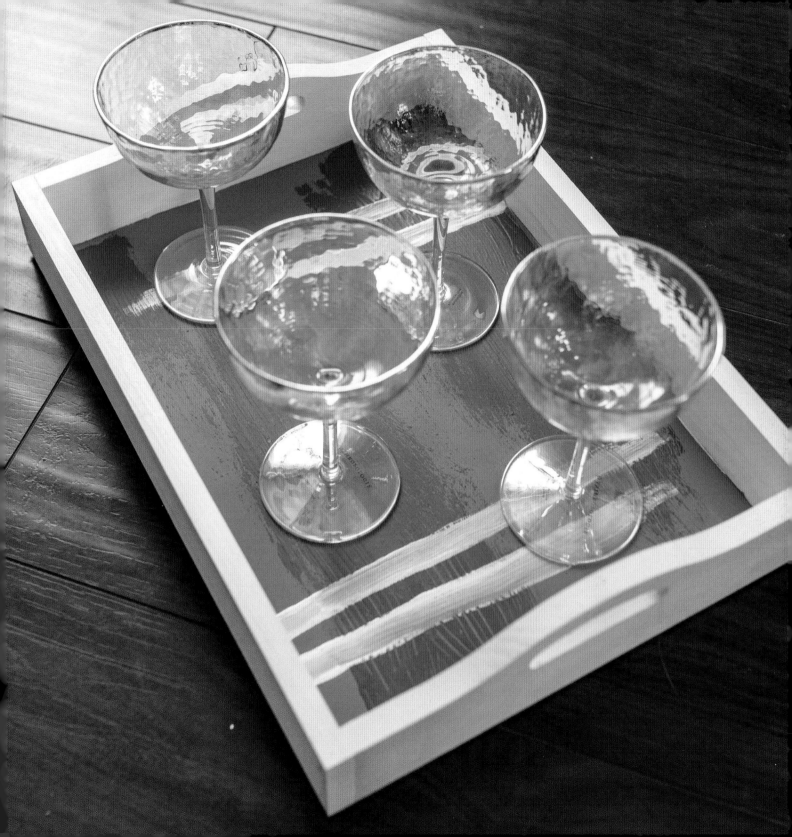

TOOLS

☐ 1 drop cloth

☐ 3–4 brushes in varying sizes

MATERIALS

☐ 1 wooden serving tray

☐ 1 roll painter's tape

☐ 1 sample size light blue paint

☐ 1 sample size white paint

☐ 1 sample size dark blue paint

PREPPING

Lay down a drop cloth. Tape the inside lining of the tray so you can paint the bottom without getting paint on the sides.

PAINTING

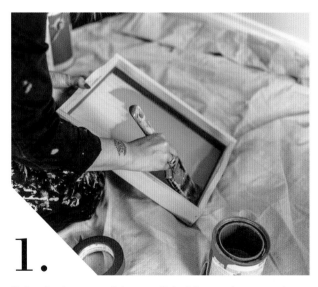

1.

Paint the bottom of the tray light blue and remove the tape while the paint dries.

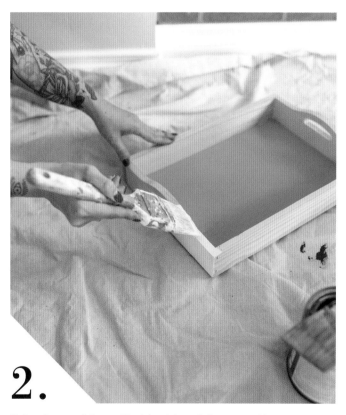

2.

Paint the outside and inside sides of the tray white.

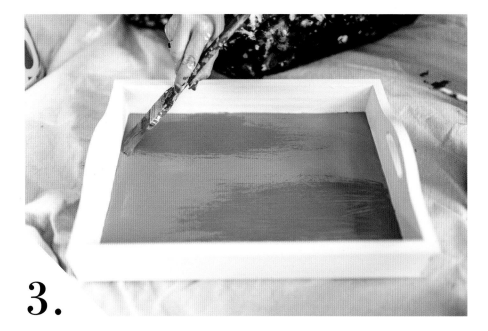

3.

Add a little bit of paint, in a darker shade than your base color, to a dry brush. Create streaks coming from the left and right sides of the tray. This will give the tray some painterly texture and is supposed to look messy, so don't worry about getting it perfect.

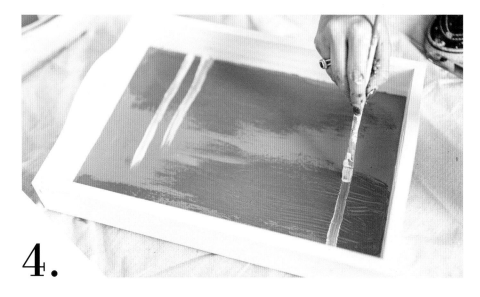

4.

When that is dry, paint imperfect white lines on either side of the tray, overlapping what you've already painted. Pop the champagne, because you just created a work of art. Cheers to that!

We like the messy paint style, so we worked with a dry brush for added texture.

ACKNOWLEDGMENTS

Thank you to everyone who let us invade their home and paint up their personal space. We are extremely grateful to all the homeowners (and renters) who were open to murals and allowed us some creative freedom—all during a global pandemic. We were halfway through the book when the state of California went into lockdown, throwing a wrench in our painting plans and the timeline for this book. However, everyone was flexible and understanding, and we truly appreciate that!

Thank you to our families for supporting us on both the good and bad days. This book took a lot of time and effort, and we are lucky to have had you by our sides the whole way through! Honestly, we should thank you for even encouraging us to be muralists in the first place because it's not the most common career choice.

Thank you to our agent, Leslie, and to the team at Storey for making this book happen. We are grateful that you saw something in us, believed in us, and helped us bring our very first book to fruition. Cheers to many more collaborations!

Thank you to our fans of our various social media accounts for cheering us on along the way. You're the people who inspired this book. Your questions and curiosity about our process fueled each and every project we included. Thank you for your interest in our craft and for the continued support.

Last, but not least, thank you to our photographers, Robin and Melissa, for your incredible work. This book would be nothing without the photos, and we are forever grateful for your time and skill. Oh, and thank you for watching paint dry with us!

METRIC CONVERSIONS

LENGTH

To convert	to	multiply
inches	millimeters	inches by 25.4
inches	centimeters	inches by 2.54
inches	meters	inches by 0.0254
feet	meters	feet by 0.3048

VOLUME

While paint is sold in quarts and gallons in the United States, paint can sizes differ greatly in other parts of the world. If you are in a country that uses metric measurements, look for liter-size cans instead of quarts and 4-liter cans instead of gallons.

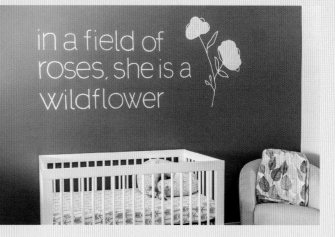

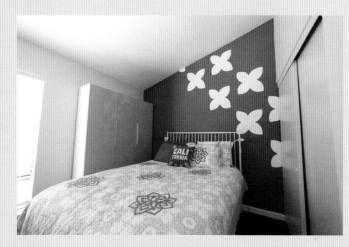

DOWNLOAD OUR DESIGNS

To download our designs for the projects listed below, visit: www.storey.com/wonder-walls-mural-designs.

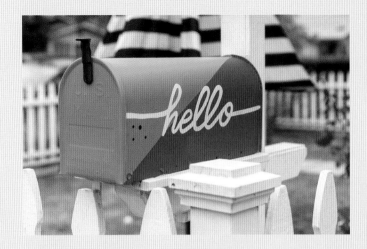

INDEX

Page numbers in *italic* indicate illustrations and photographs.

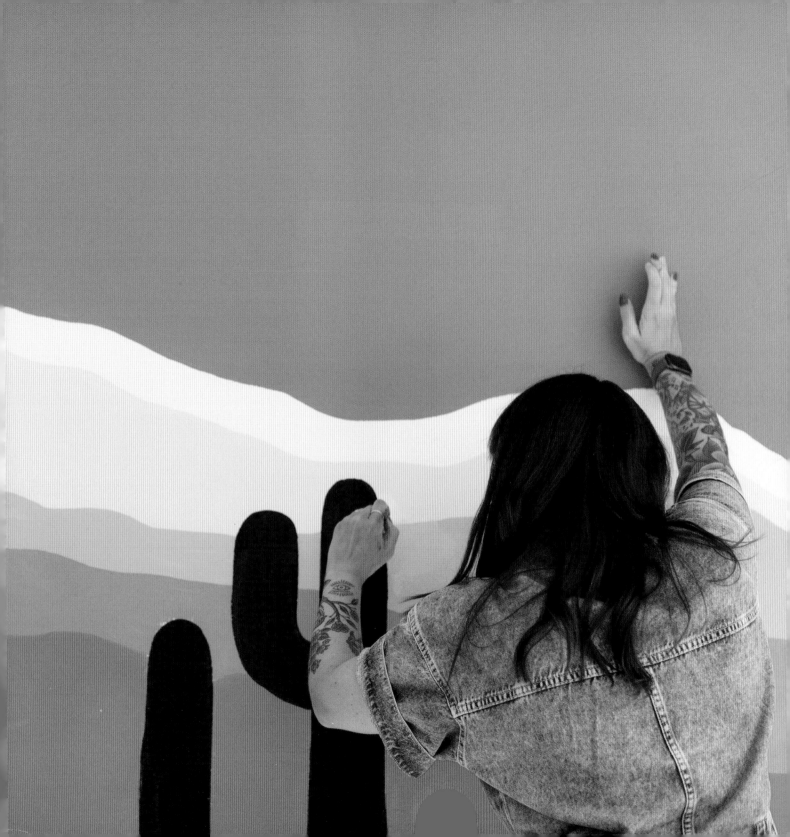

The mission of Storey Publishing is to serve our customers by
publishing practical information that encourages
personal independence in harmony with the environment.

33614082469957

Edited by Liz Bevilacqua and Mia Lumsden
Art direction by Ash Austin
Book design by Mia Johnson
Text production by Liseann Karandisecky
Indexed by Samantha Miller

Cover photography by Melissa McClure © Pandr Design Co.,
front & back flap, (m. & b.) and Robin Bigge of Byrd
Photography © Pandr Design Co., front flap, back, back
flap (t.), spine, inside front & back

Interior photography by Robin Bigge of Byrd Photography
 © Pandr Design Co., except 8, 16, 24, 27, 43, 46 l., 142–145,
 156–161, 172–177 by Melissa McClure © Pandr Design Co.

Script lettering and illustrations © Pandr Design Co.

Text © 2021 by Phoebe Cornog and Roxy Prima

The information in this book is true and complete to the
best of our knowledge. All recommendations are made
without guarantee on the part of the authors or Storey
Publishing. The authors and publisher disclaim any liability in
connection with the use of this information.

Storey books are available at special discounts when
purchased in bulk for premiums and sales promotions
as well as for fund-raising or educational use. Special
editions or book excerpts can also be created to
specification. For details, please call 800-827-8673,
or send an email to sales@storey.com.

Storey Publishing
210 MASS MoCA Way
North Adams, MA 01247
storey.com

Printed in the United States by Versa Press
10 9 8 7 6 5 4 3 2 1

Library of Congress Cataloging-in-Publication Data on file